Wildflowers

Nature's Stunning Beauty in Full Bloom

Stan Tekiela

Adventure Publications
Cambridge, Minnesota

Dedication

To my father, who showed me how to be a man and also love wildflowers.

Acknowledgments

Special thanks to Rick Bowers, wildlife biologist and extraordinary friend, for reviewing this book. I am continually impressed and amazed at your in-depth knowledge of wildflowers.

Edited by Sandy Livoti

Cover and book design by Lora Westberg

Cover photos by Stan Tekiela: Wood Lily (front), late summer wildflowers (back top), native prairie and Blazing Stars (back bottom), Wild Daffodil (front flap)

All photos by Stan Tekiela except pp. 39 (Yellow Bells) and 55 (Organ Pipe Cactus) by **Rick and Nora Bowers**, and as noted.

Used under license from Shutterstock.com:
DM Larson: 106, **Gelia:** 97, **gregg williams:** 132, **JuliyaM:** Cover (flower on spine), **Kazakov Maksim:** 130, **MadeK:** 61

Wildflowers

Nature's Stunning Beauty in Full Bloom

Table of Contents

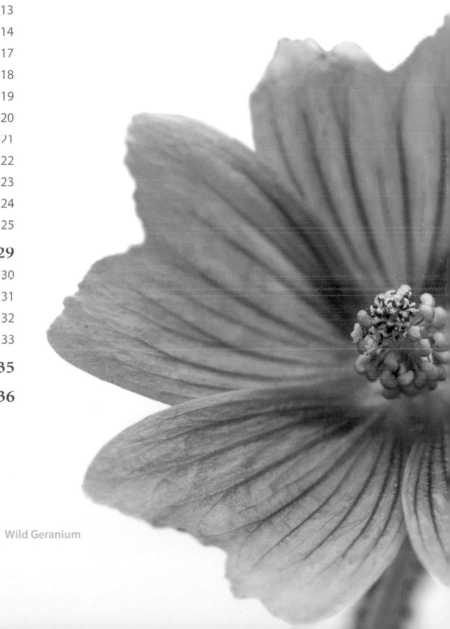

Wild Geranium

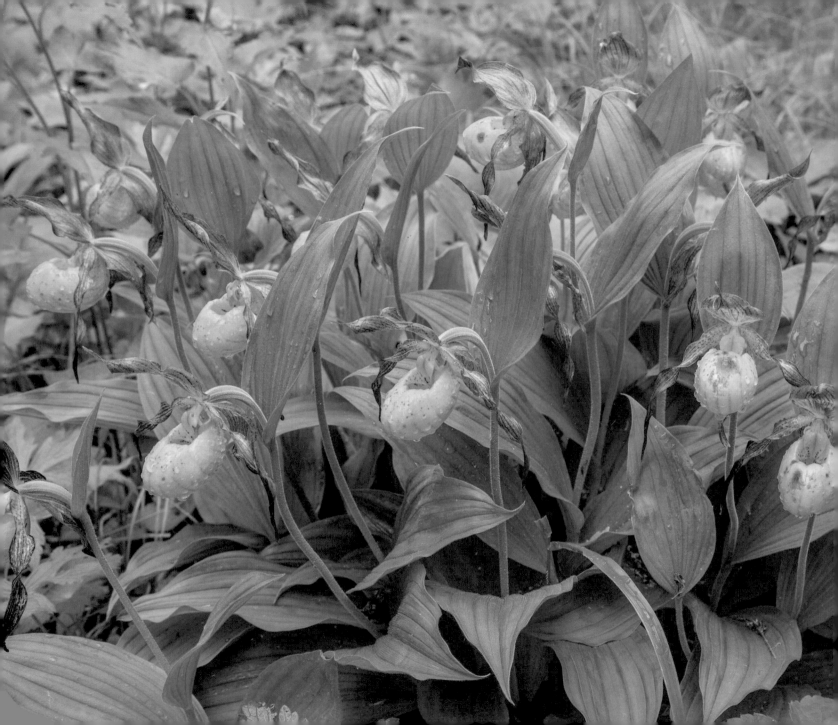

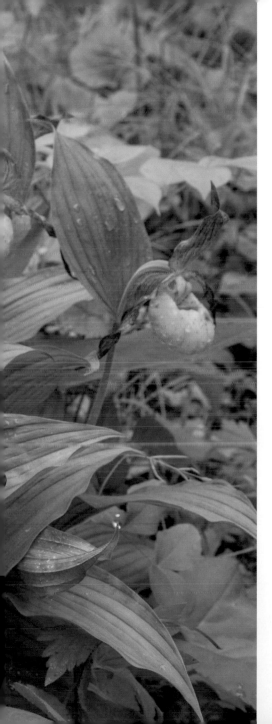

Yellow Lady's Slipper

A Note from Stan

Wildflowers are more than just natural decorations. Flowers enable a plant to produce seeds, helping the species to survive. This knowledge should be enough to discourage you from picking a wildflower or, worse yet, digging up a plant.

Nearly all city, county and state parks, along with national parks and refuges, have laws to help protect our precious wildflowers. For example, digging up wild orchids, such as lady's slippers, is illegal in many states. On federal lands, it is illegal to dig or pick any orchids.

Poaching wildflowers is the process of digging wildflowers out of the ground, usually to bring them home or, even worse, to sell them. Poaching is a highly illegal and unethical practice that should never be tolerated.

Please do the right thing and never pick or dig (poach) wildflowers. Leaving wildflowers where you find them allows others to also enjoy the splendor of the blooms, and gives the species a chance to reproduce, ensuring future generations of these magnificent plants.

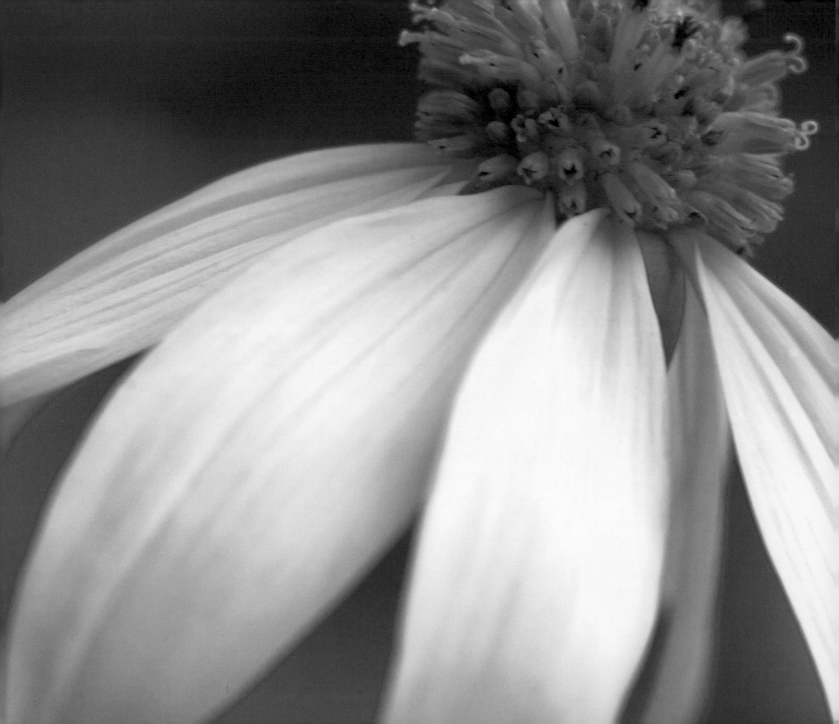

The Mystery of Wildflowers

Wildflowers are a lot like wild birds. People are drawn to their beauty and fascinated by their life cycles. We may not know why we like them so much, but we just do!

I have always thought of myself as a big-picture naturalist—an old-school naturalist who is just as interested in plants as birds, animals and insects. The roles that plants play in the natural world fascinate me, and they draw me to wildflowers. I try to capture all of the natural beauty with my camera, from a field packed full of wildflowers down to the tiny and intricate parts of a flower itself.

We love the mystery of wildflowers. Delicate and ephemeral, they have the ability to reach a place deep inside us and inspire a sense of peace. It's wonderful how they add color to a green landscape or backyard and charm to our homes. From their graceful beauty to their cheery colors and gentle fragrances, wildflowers help us feel satisfied and fulfilled. This is why I love wildflowers.

Green-headed
Coneflower

WILDFLOWERS: BEAUTY FOR LIFE

Plants are the basis for all life on the planet. While this might sound like an outlandish and grandiose statement, it is indeed a fact. I don't believe we can overstate the importance of plants. Plants don't do just a few things to help other forms of life to survive. No, the list of benefits from all types of plant life is very long.

To start, green plants produce the oxygen we breathe. They help keep our planet cool and moist by providing shade and ground cover, which reduces evaporation. Their shade protects us from the sun's bombardment of ultraviolet light. They also help control the climate by storing the excess carbon produced from the burning of fossil fuels.

In the past, plants constituted all of the active ingredients in early medicines. Today, plants still constitute over 25 percent of the vast variety of our prescription drugs. The active ingredient in many of these medicines, as well as over-the-counter drugs, comes directly from a plant or is a derivative from a plant.

Everything we eat comes directly or indirectly from plants. Throughout our history, more than 7,000 types of plants have been used for food. Plants also feed the animals that we, in turn, consume.

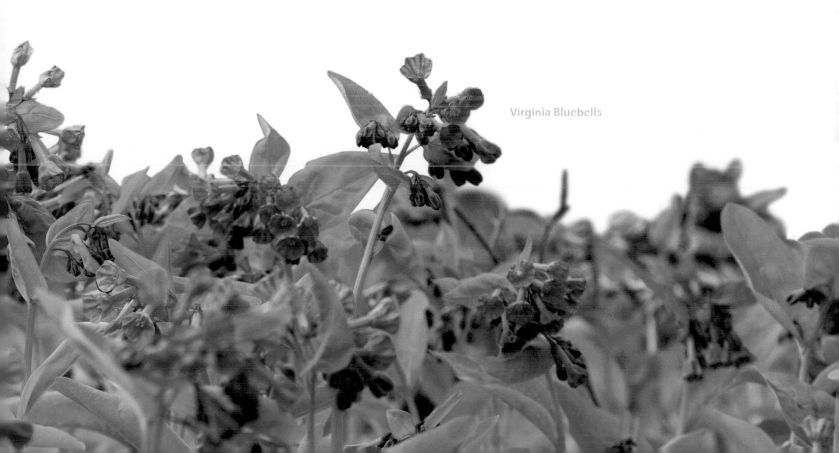

Virginia Bluebells

Plants provide us with life-giving oxygen. Oxygen is a waste by-product of plant photosynthesis, the food-making process in which a plant takes in sunlight and carbon dioxide.

Plants thrive in many different types of habitats, and each habitat has different kinds of plants. They include coniferous forests, deciduous forests, prairies, grasslands, scrublands, deserts, rain forests, tundra and so much more.

There are over 350,000 different kinds of plants on the earth. They range from tiny green plants no bigger than a grain of rice all the way up to massive redwood trees, which can stand over 300 feet tall. Some plants have very short lives of only a couple of weeks, while some trees have life spans of more than 5,000 years.

**Yellow Trillium
and Fire Pink**

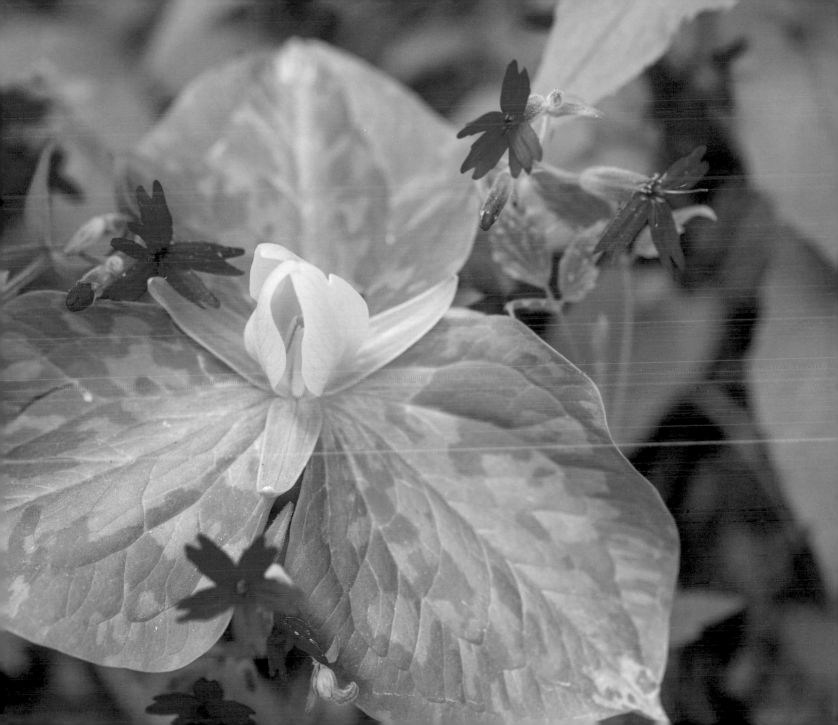

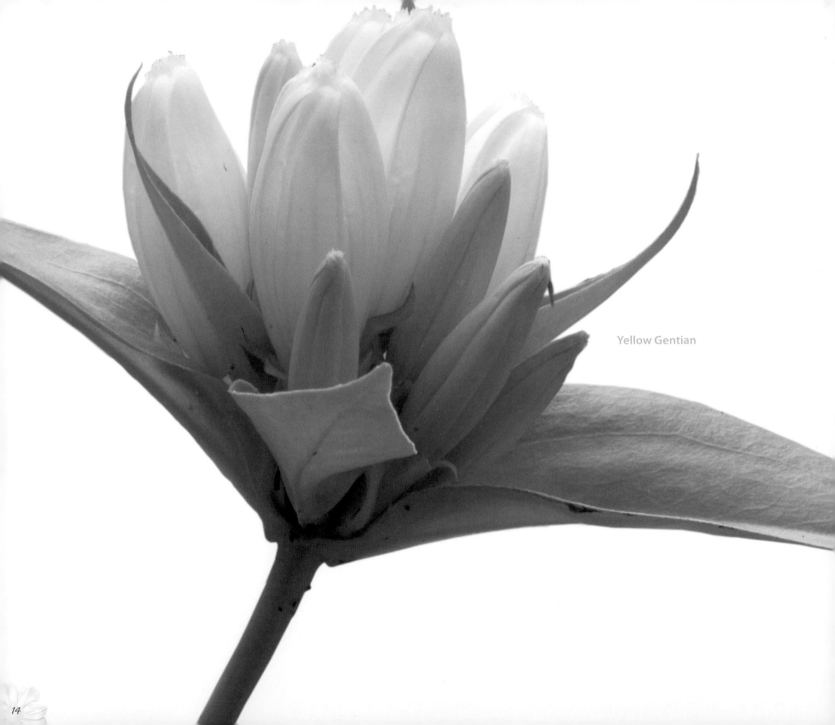

Yellow Gentian

Most plants have flowers. Some flowers are tiny and inconspicuous. Others are large and flashy. Wildflowers are one type of flowering plant. The term "wildflower" in general defines small ground-dwelling (terrestrial) plants with small to large colorful flowers, and usually refers to native plants that reproduce on their own in the wild. Wildflowers are typically soft-stemmed (herbaceous) plants that die back to the ground each winter.

For this book, I define a wildflower as any of the herbaceous terrestrial plants that produce a conspicuous flower. The flower can be colorful or white, and the plant can be an annual, biennial or perennial that usually dies back to the ground each winter. Wildflowers usually reproduce freely in the wild. They can be rare or exceedingly common. No matter the shape, size, color or abundance, these plants have wonderful flowers that delight us and warm our hearts.

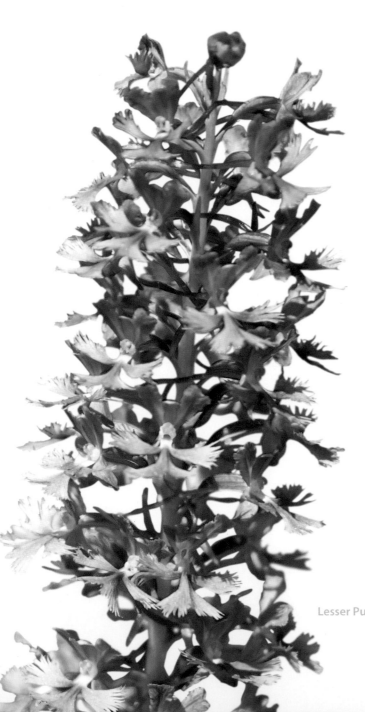

Lesser Purple Fringed Orchid

FLOWER APPEAL

Wildflowers are gorgeous, even dazzling, but they aren't here to show off for us. Instead, they're here to attract insects to pollinate their blooms in order to produce seeds and reproduce the plant. That's it!

When we admire a wildflower, we are admiring the form and function of nature. The elaborate flower of a wild orchid, for example, attracts a specific type of insect. The insect inadvertently picks up some grains of pollen and carries them to another flower, which achieves cross-pollination. Cross-pollination moves the pollen from one flower to another and mixes up the genes, producing genetically stronger plants. Flowers are what attract an insect's attention, leading it to visit and pick up pollen.

When you think of wildflowers, think of pollination. The pollination system is, for the most part, a mutual relationship between plants and insects. The plants benefit reproductively since cross-pollination by insects enables reproduction and produces healthier plants. The insects benefit physically from the nutritious rewards of consuming the nectar and pollen in the plants.

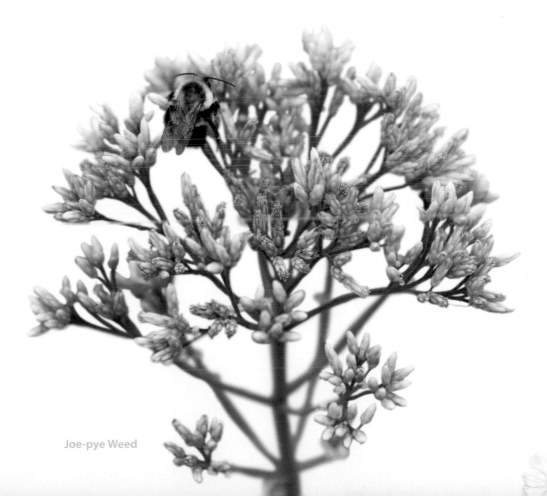

Joe-pye Weed

HIGH-ENERGY NECTAR

Insects and some birds visit wildflowers to get the tasty treat of nectar. Nectar is a sweet, high-energy liquid food produced by the plant and held in the tubular part of the flower just below the petals, called the corolla. Nectar is there solely to reward a visitor.

Nectar is composed of water and sugar. In most wildflowers, nectar is made up of about 75 percent (three-quarters) water and 25 percent (one-quarter) sugar. The sugar is normally a combination of three different sugars: sucrose, fructose and glucose. The sugars fuel the activity of fast-flying insects and hummingbirds.

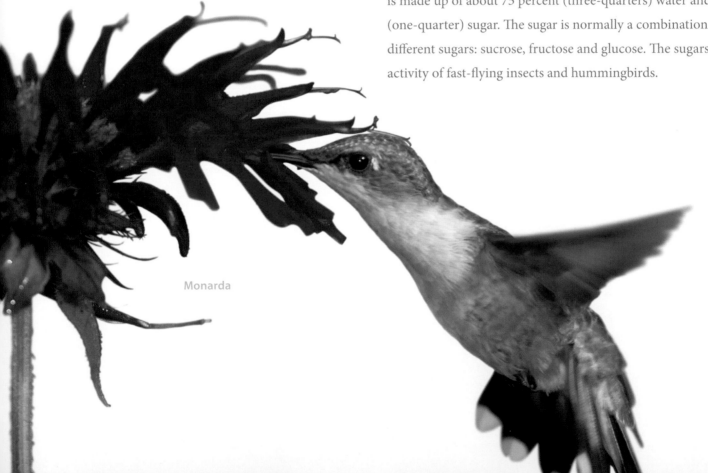

Monarda

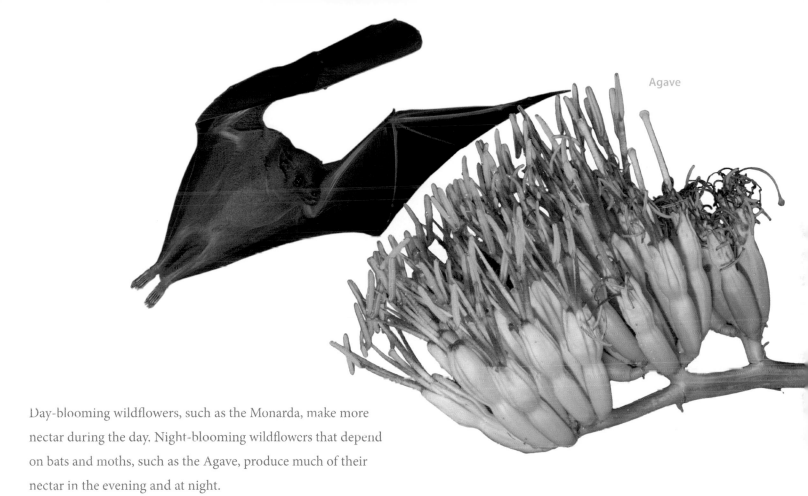

Agave

Day-blooming wildflowers, such as the Monarda, make more nectar during the day. Night-blooming wildflowers that depend on bats and moths, such as the Agave, produce much of their nectar in the evening and at night.

Studies showed that wildflowers that are visited at a higher rate produce more nectar in response to the demand. The studies also showed that when a wildflower is completely pollinated, fertilization is complete and seeds are starting to develop, nectar production stops. There is no need to reward visitors if the job of pollination is finished.

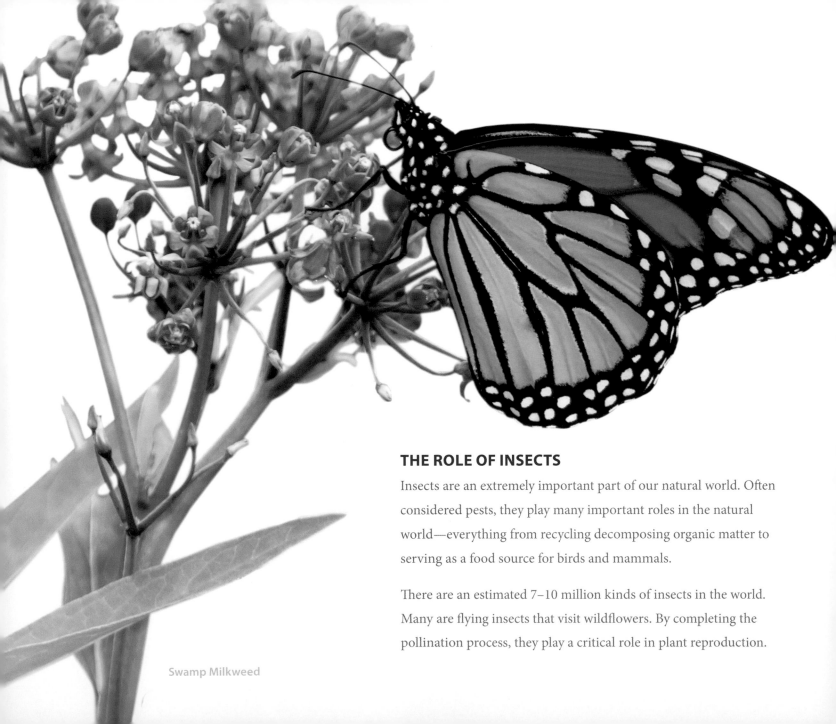

THE ROLE OF INSECTS

Insects are an extremely important part of our natural world. Often considered pests, they play many important roles in the natural world—everything from recycling decomposing organic matter to serving as a food source for birds and mammals.

There are an estimated 7–10 million kinds of insects in the world. Many are flying insects that visit wildflowers. By completing the pollination process, they play a critical role in plant reproduction.

Swamp Milkweed

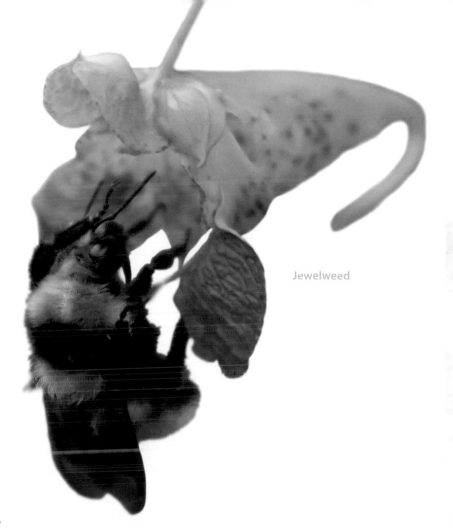

Jewelweed

POLLEN AND NUTRITION

Most flowers produce loose, individual grains of pollen. Single grains of pollen are usually microscopic and too small to see with the naked eye. When loose pollen collects in abundance, such as on the bill of a hummingbird or on the leg of a bee, it often appears as a yellow powder.

Some individual grains of pollen are so tiny that the wind blows them around. Other deposits of pollen are too large to float on the breeze and require insects or birds and other creatures to move them. Trees and grasses are typically wind-pollinated, so their flowers are usually small, green and not very attractive. Wildflowers tend to have large and showy flowers that attract insects, which carry the pollen from flower to flower.

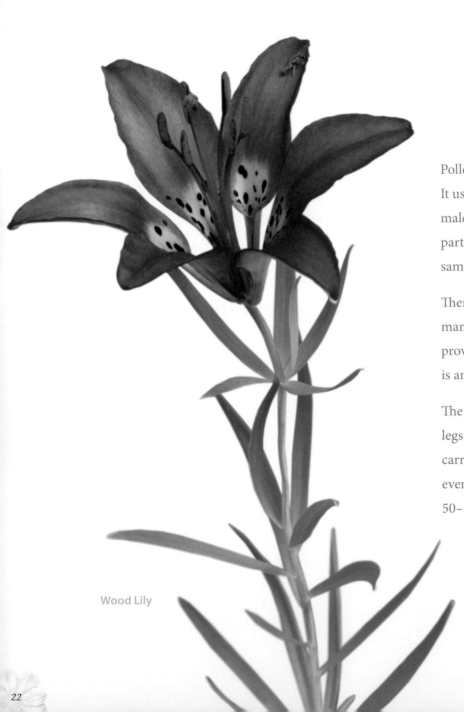
Wood Lily

Pollen is generally the male reproductive part of the plant. It usually has a hard coat or outer covering that protects the male germ cell (gamete) during movement from the male part of the wildflower to the female part, either within the same flower or from one flower to another.

There is a lot of nutrition in pollen, and that may be why many species of bees, especially honeybees, collect it. Pollen provides protein, carbohydrates, vitamins and minerals, and is an essential part of the honeybee diet.

The bees stuff the pollen into a receptacle on their hind legs, called the corbicula, or pollen basket. A single bee can carry about half of its own body weight in pollen. What's even more amazing is that a colony of bees can bring 50–100 pounds of pollen back to the hive each season!

Pollinia

SAC POLLINATION

Some flowers, namely the milkweeds, produce masses of pollen grains in waxy collections or sacs, called pollinia. The only other plants known to produce pollinia for reproduction are the orchids.

Milkweeds are herbaceous wildflowers that tend to have clusters of brightly colored flowers with abundant nectar. There are more than 100 milkweed species in North America. These plants are well known for their association with Monarch butterflies. Monarchs lay their eggs only on milkweeds, and the resulting caterpillars feed on the leaves.

Swamp Milkweed

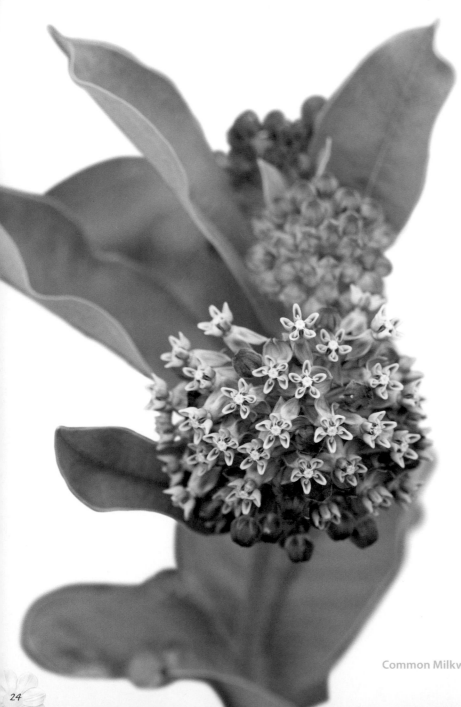

Bees and other insects that visit milkweed flowers don't collect pollen. They just sip the nectar. Due to the star-shaped structure of the flowers, insects must stand in specific positions to feed. The flowers have five individual horns, or hoods. Between each horn is a small slit, or opening, called the stigmatic chamber, where pollinia are housed. To get to the nectar, a visiting insect needs to stand with its legs between the horns and inside the chamber. There, a sticky pad with two sacs of pollen attaches to the legs, appearing like saddlebags on the legs when the insect pulls out of the chamber.

Common Milkweed

Only large and robust insects, such as bumblebees, are strong enough to carry sacs of pollen. However, sacs don't attach to insects that are overly large or that stand too far away while sipping the nectar. Smaller insects that accidentally slip their legs into the slits often get trapped in the flower and die. Some lose their legs to the flower while trying to break free, but they are still able to fly off.

Once the pollinia attaches to an insect's legs, the insect needs to fly to other flowers that have the receptive parts to receive the pollen sacs. In sac pollination, since one pollinia sac contains hundreds, if not thousands, of pollen grains, one visit to sip nectar will result in the pollination of many flowers.

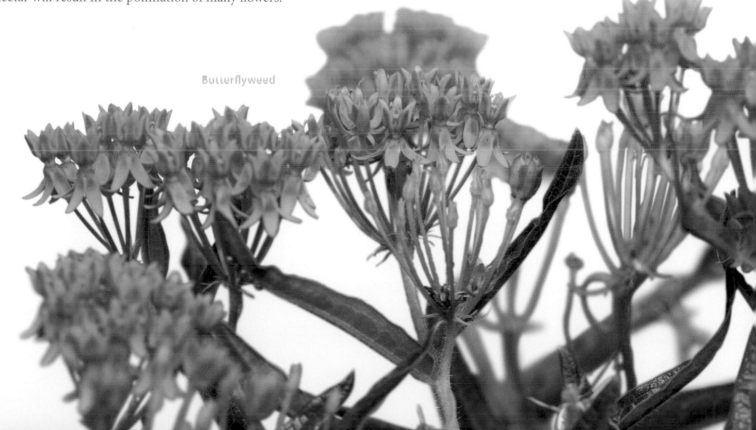

Butterflyweed

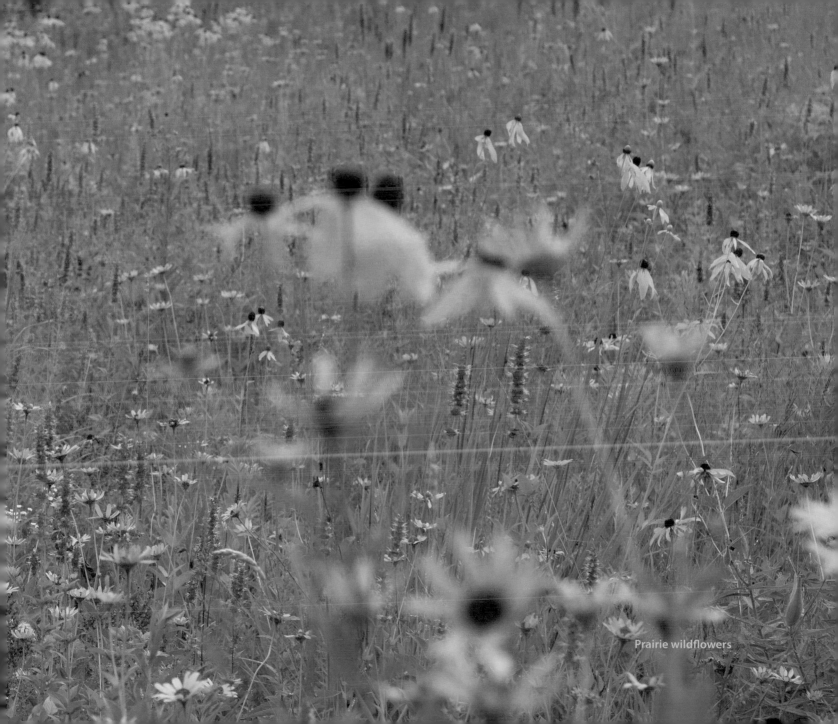

Prairie wildflowers

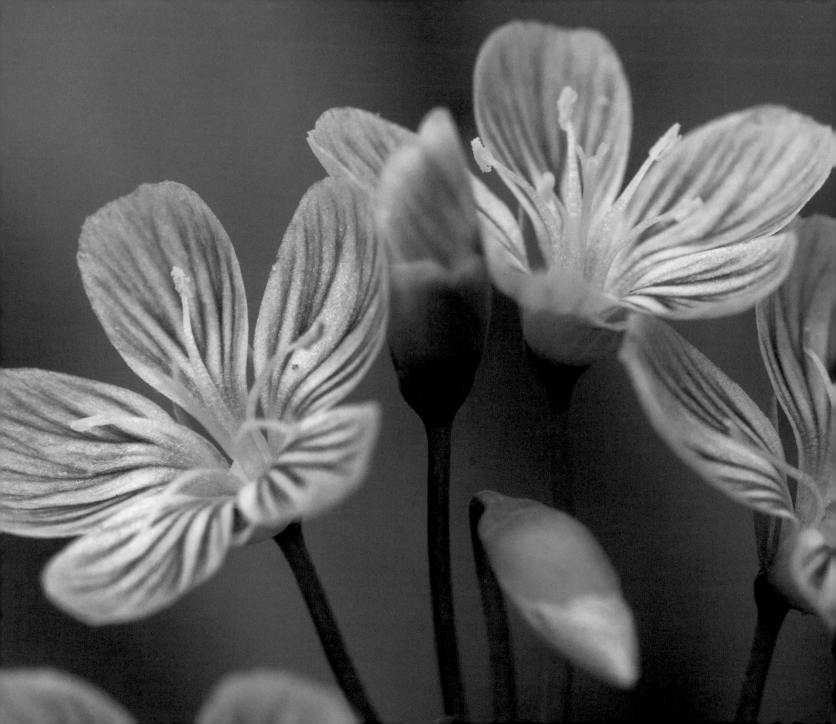

Flower Parts and Parcels

Wildflower plants are often grouped into categories by the type of bloom they produce to attract insects. There are often slight variations in each group, so there are no hard-and-fast rules.

When you're learning about wildflowers, it's important to understand the various parts of a flower. Together, all of the parts make up a flower and allow for the production of seeds.

Spring Beauty

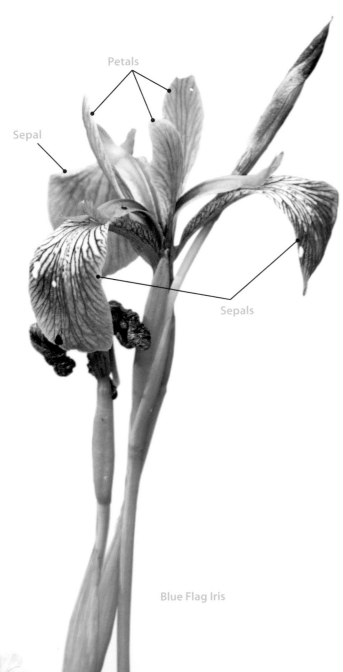

Petals

Sepal

Sepals

Blue Flag Iris

FOUR PARTS OF FLOWERS

When we look at an eye-catching wildflower, we may think of it as one structure or one part of the plant. In most species of wildflowers, however, each flower is made up of four parts: sepals, petals, stamen and pistil.

Sepals are at the base of the flower. These are often green and look like tiny leaves. They are, in fact, considered to be modified leaves. Sepals enclose the flower as it develops and provide protection. When the flower opens, sepals often unfurl to support the petals.

In some flower species, sepals are the same color as the petals. When this happens, they are often very hard to tell apart. Collectively, the sepals are called the calyx.

Above the sepals are the petals. Petals are often brightly colored and unfurl into interesting shapes. Flower petals are also considered to be modified leaves.

Petals are usually shaped to attract specific pollinators. They can be large and flashy, as seen in the Blue Flag Iris, or tiny, such as those of the Aborted Buttercup. Petals can be separate and radiate out from a central point, or they can join or fuse together to form a tube. When petals radiate or fuse, they are called the corolla.

Inside the arrangement of sepals and petals are the reproductive parts of the flower. Most flowers have both male and female parts. Some plants have flowers with only male parts. Others have only female parts.

Petal

Style

Stigma

Pistil

FEMALE PARTS

MALE PARTS

Filament

Anther

Stamen

Turk's Cap Lily

31

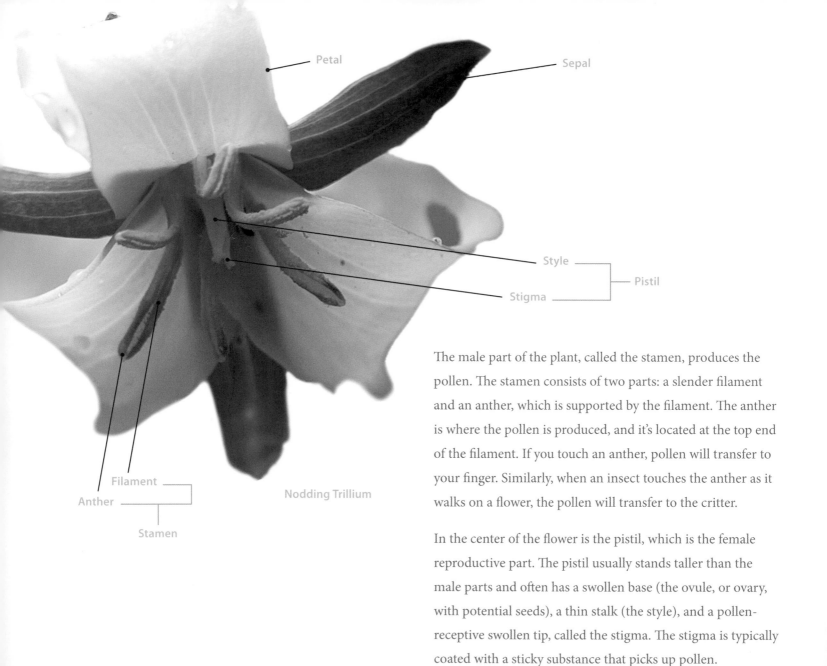

Petal

Sepal

Style

Pistil

Stigma

Filament

Anther

Nodding Trillium

Stamen

The male part of the plant, called the stamen, produces the pollen. The stamen consists of two parts: a slender filament and an anther, which is supported by the filament. The anther is where the pollen is produced, and it's located at the top end of the filament. If you touch an anther, pollen will transfer to your finger. Similarly, when an insect touches the anther as it walks on a flower, the pollen will transfer to the critter.

In the center of the flower is the pistil, which is the female reproductive part. The pistil usually stands taller than the male parts and often has a swollen base (the ovule, or ovary, with potential seeds), a thin stalk (the style), and a pollen-receptive swollen tip, called the stigma. The stigma is typically coated with a sticky substance that picks up pollen.

PERFECT AND IMPERFECT FLOWERS

When a flower has all four parts (sepals, petals, stamen and pistil), it is considered a perfect or complete flower. When one or more of the four parts is missing, it is considered an imperfect or an incomplete flower. Not all flowers have both male and female parts. Some imperfect flowers have just the male parts containing the pollen. Others have just the female parts.

Some wildflower species have both male and female flowers growing on the same plant. In other species, the male and female flowers grow on separate plants. When male and female flowers grow on the same plant, the species is said to be monoecious. This term means "one household." When male and female flowers of the same species grow on different plants, the species is called dioecious, meaning "two households."

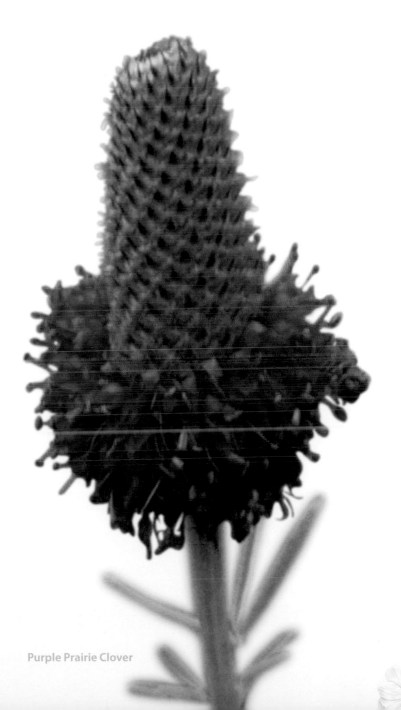

Purple Prairie Clover

33

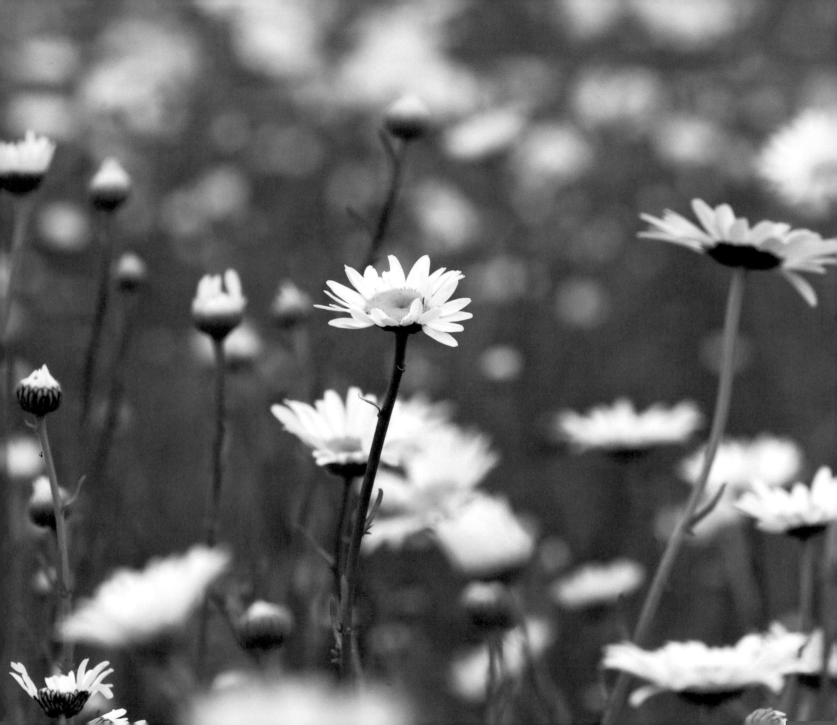

COMPOSITE FLOWERS

When you think of a wildflower, you might imagine a daisy-like flower with many petals surrounding a central disk. This kind of flower is called a composite flower. Composite flowers are in the Asteraceae family, more commonly known as the aster family, the daisy family or the sunflower family. Asteraceae is considered to be the largest and most widespread family of flowers.

A composite flower looks like one single flower, but it is actually made up of a cluster of dozens, or sometimes hundreds, of tiny flowers. The central disk of a daisy-like flower, for example, is composed of many tiny flowers packed tightly together, called disk flowers. Each of these flowers will become pollinated and produce a seed.

The large petals that surround the disk and often give the flower its color are actually a collection of individual flowers, called ray flowers. So if you pluck off the petals of a daisy, you are pulling off individual flowers. Take a moment to look at the base where the petals attach, and you will see the reproductive parts of the flower. Like disk flowers, each of the ray flowers will become pollinated and produce a seed.

All of the coneflowers, such as the popular Purple Coneflower, are composite flowers. They have central disk flowers surrounded by ray flowers. Even the Common Dandelion is a composite flower! If you examine one, you will see that it is a collection of dozens of tiny ray flowers. You can dissect a dandelion and remove each ray flower to see and appreciate all of the flower parts.

Ox-eye Daisy

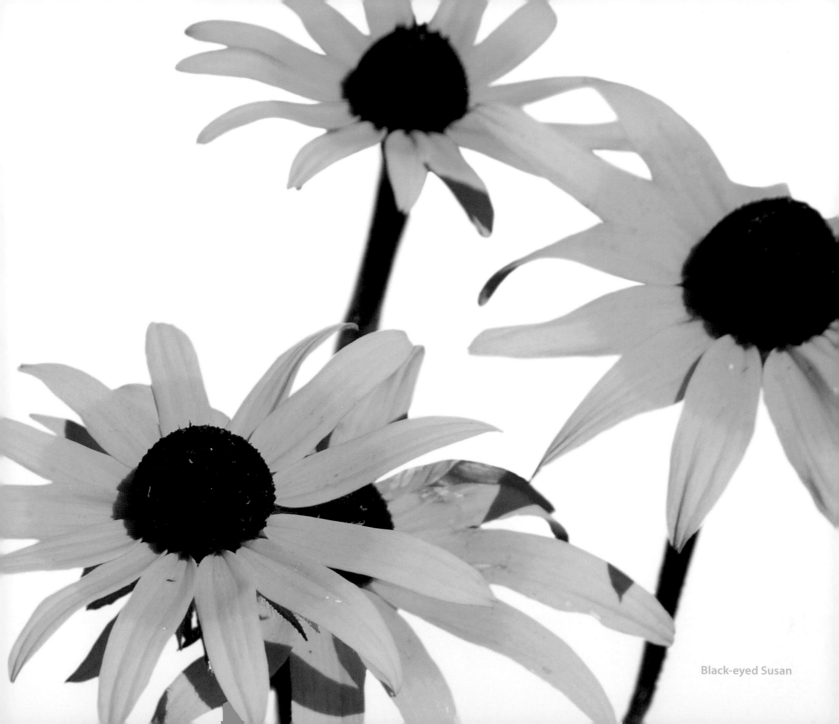

Black-eyed Susan

PETALS FOR LANDING

Think of the petals of a composite flower, such as a daisy, as landing pads for insects. Brightly colored petals or patterns in the petals will attract insects, but when one approaches, it will need a large and stable landing platform.

Plants with large flat-topped flowers often attract larger insects that can't land easily, like butterflies and moths. While these insects are good-looking, they are not very good at landing on small or delicate flowers.

In addition, many of these flowers have "hidden" lines that you and I can see only when viewed under ultraviolet (UV) light. They point toward the nectar and guide insects, which see primarily in UV light, to the sweet liquid deep inside the flower. These lines are called nectar guides.

The size of wildflowers is not random, but rather determines which insects can visit and which are not welcome. Tiny flowers, as seen in the Aborted Buttercup, attract tiny flying insects. If a large bumblebee landed on this weak-stemmed plant, the flower and the bee would no doubt droop down to the ground.

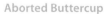

Aborted Buttercup

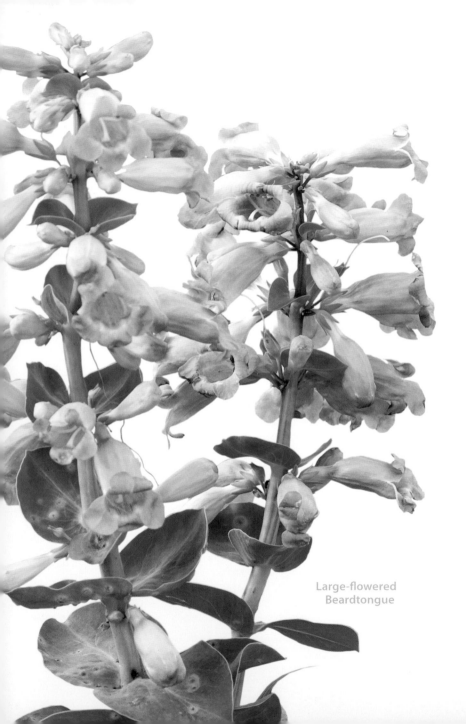

Large-flowered
Beardtongue

SHAPED TO FEED

The shape of a flower will also attract specific kinds of insects and birds. Like size, shape dictates the kinds of insects that can visit a flower to feed and those that can't. For example, the length of the tube that leads to the nectar limits the insects that can feed. Only insects with longer tongues, or mouthparts (proboscises), are able to reach down far enough to sip the sweet liquid. All others are excluded.

Some flowers have one large tube-like structure, or a corolla, where all of the petals have fused to form a tube. Other flowers have many tiny tubes in a collection that looks like one big flower but is actually many flowers. Hummingbirds, along with insects like butterflies and moths, have tongues long enough to reach deep into tube flowers, such as Large-flowered Beardtongue, to get the nectar.

NECTAR ROBBERS

While most insects use the "main entrance" of a flower to get to the nectar, some insects can't reach it, and opt for a different tactic. Known as nectar robbers, these insects chew a hole in the side of a flower near the base, where the nectar is stored. They sip the nectar through the chewed opening without making contact with the reproductive parts of the flower, so they don't help the flower reproduce via pollination. This is considered a form of flower exploitation by the insect.

Columbine

Yellow Bells

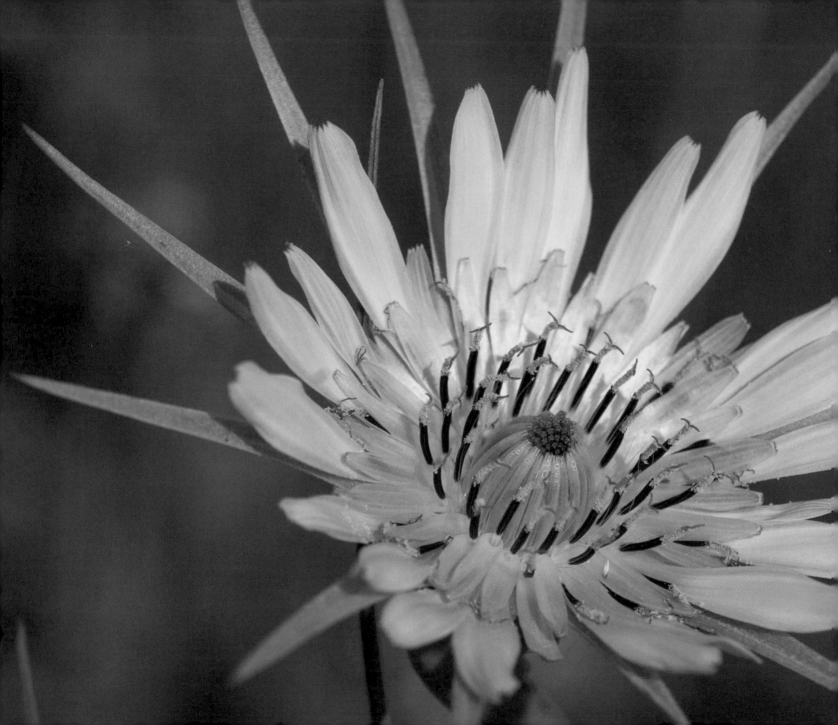

Colors and Fragrances

Wildflowers appear in many dazzling colors. From elegant white to eye-popping red, flowers add so much appeal to our landscapes. In addition, many wildflowers not only look great, but they also have remarkable fragrances.

When a flower is ready for pollination, it produces the most fragrance. Some flowers put out the most scent during the day. Others perfume the air at night. Most wildflowers have a pleasing scent, while others give off an unpleasant odor. All of the colors and scents combine to make wildflowers a visual and aromatic beacon to insects and bats.

Yellow Goat's Beard

PIGMENTS MAKE THE COLORS

Wildflowers bloom in an array of stunning colors. Most colors are the result of carotenoid or anthocyanin pigments. Yellow, orange and red come from carotenoids. Red also comes from anthocyanins, as well as pink, blue and purple.

More than 60 carotenoids have been isolated in plants. Carotenoids are some of the most common plant-coloring compounds in the natural world. The presence of carotenoids is why yellow is one of the most common wildflower colors.

Carotenoids occur throughout the entire plant, including the roots. Many plants have yellow or orange roots due to the carotenoid pigments.

Carotenoids are rugged compounds. They don't break down in sunlight, and they become more visible when plants wane in autumn. Carotenoids are the reason why green tree leaves turn yellow before they die.

Dwarf Crested Iris

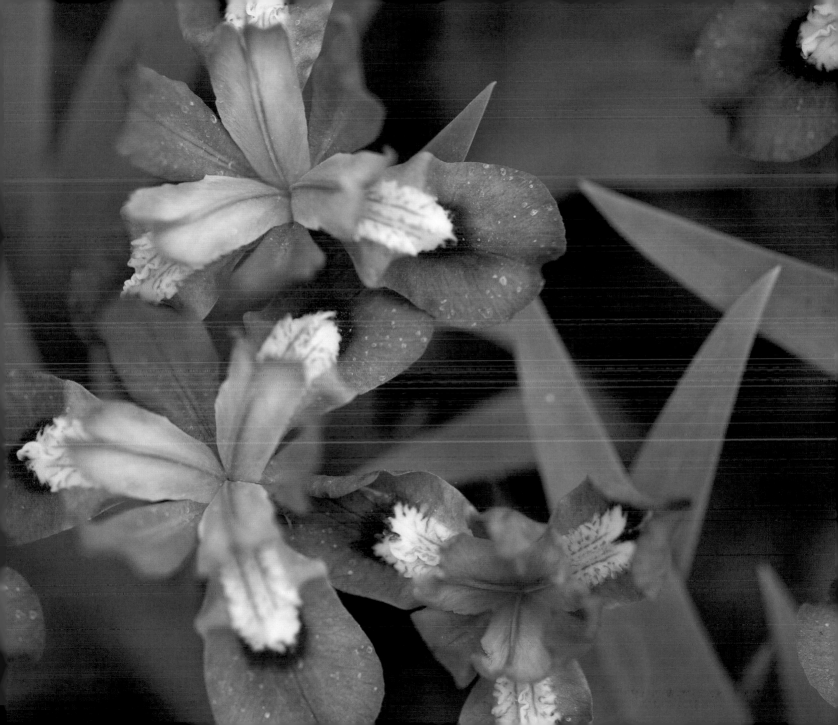

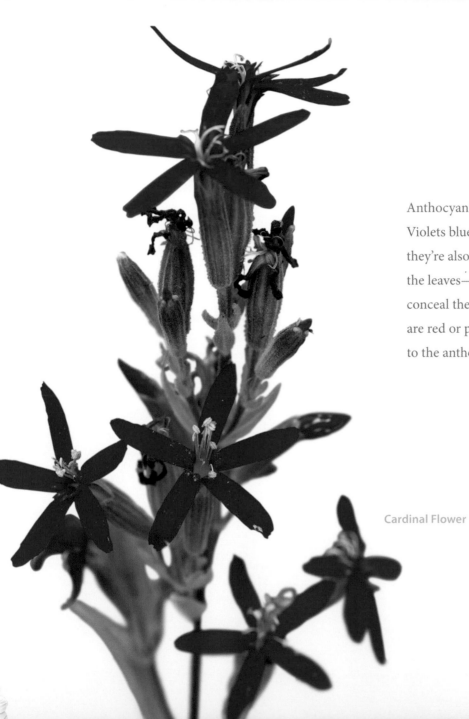

Anthocyanins make Cardinal Flowers red and Bird's-foot Violets blue. These colors are not only in the flowers, but they're also often in other parts of the wildflower, such as the leaves—although the green from the chlorophyll may conceal the anthocyanin pigments. In many plants there are red or purplish leaf hairs or red roots and leaves due to the anthocyanins.

Cardinal Flower

Chlorophyll produces a pigment that colors the stems and leaves of most wildflowers various shades of green. In some wildflower species, the flowers are also green.

Chlorophyll doesn't just add color to plants. To make food for itself, a plant utilizes chlorophyll together with sunlight and carbon dioxide, giving off oxygen as waste. This is called photosynthesis.

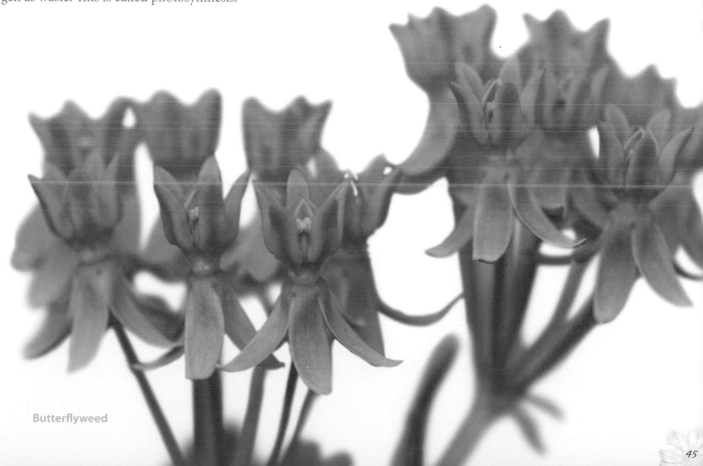

Butterflyweed

FRAGRANCES AND ODORS

The scent of a wildflower usually comes from a combination of essential oils and other chemical substances. These are usually formed in special oil-secreting cells in the petals.

In general, white flowers that open at night and attract night-flying insects have more fragrance than flashy daytime flowers. Under the cover of darkness, these flowers mainly attract moths with their pleasing fragrance. The scent carries on light night breezes and attracts night-flying pollinators far and wide.

Some flowers produce just the opposite of pleasant fragrances. Instead, they have odors that smell very similar to rotten meat! These putrid-smelling flowers attract flies and beetles that sense a free and easy meal.

One of these malodorous flowers is the Wild Ginger. This ginger is not the same ginger that you buy and use in cooking. Wild Ginger produces large brownish flowers that lay directly on the forest floor, allowing beetles and other ground-dwelling insects to walk right into the open blooms. The stinking smell and easy access attract these bugs from great distances. They crawl around the interior of the flowers, getting covered with pollen while searching for the decaying meal. Eventually they give up and move on with the pollen to another flower.

Wild Ginger

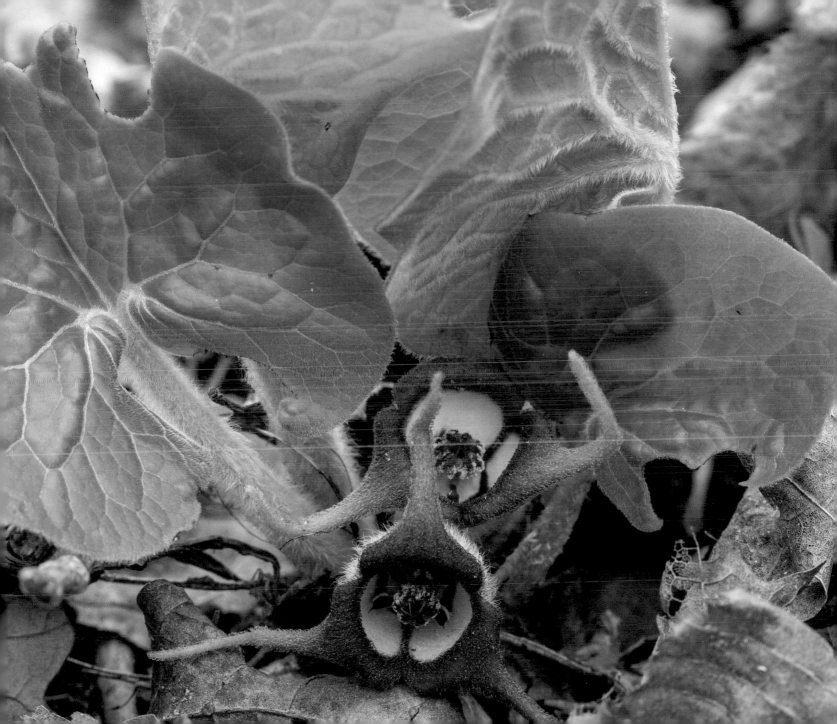

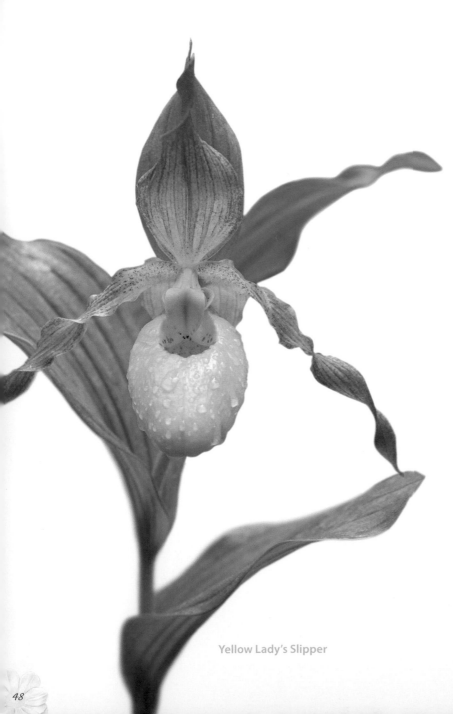

Yellow Lady's Slipper

SCENT TRICKERY

Some orchid species release a fragrance that mimics the odor of a female insect and attracts male insects to the flowers. The scent entices males to enter the flower, where they expect to find a female. There, the duped males involuntarily pick up packets of pollen before they head out to search for a female somewhere else.

In studies of marked male wasps, some males quickly learned that they were deceived and avoided the flowers. Other males repeated their visits to the flowers and were fooled over and over again.

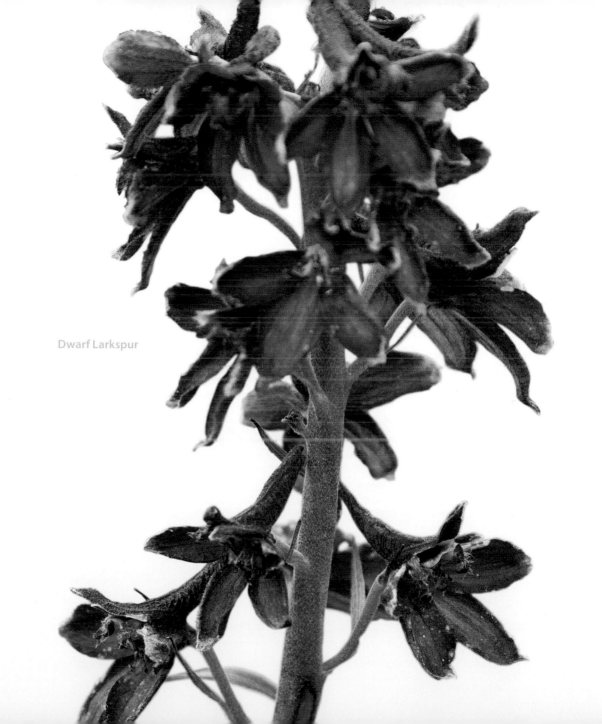

Dwarf Larkspur

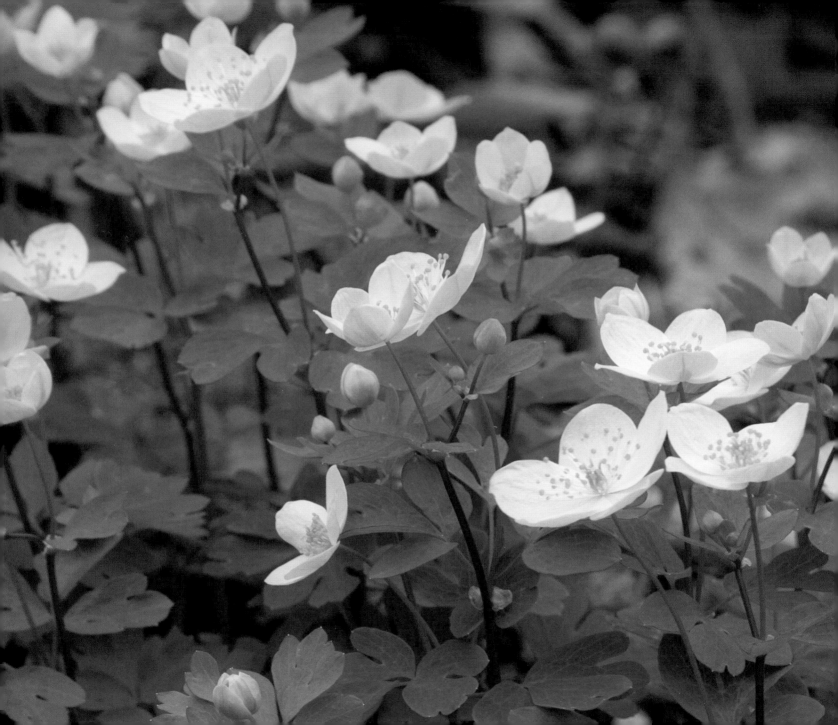

Opening and Closing

Most flowers open only once and stay open until pollination is complete. But some flowers open and close in tandem with temperatures or sunlight. The intensity of light, the air temperature, and even an internal clock will trigger a flower to open and close.

Most wildflower plants grow new cells each day on the inside of a flower to open it, and new cells on the outside to close it. Other plants open and close their blooms by pumping water in or out of the cells on the inside or the outside of the petals. This expands or contracts the cells and causes the flower to open or close.

False Rue Anemone

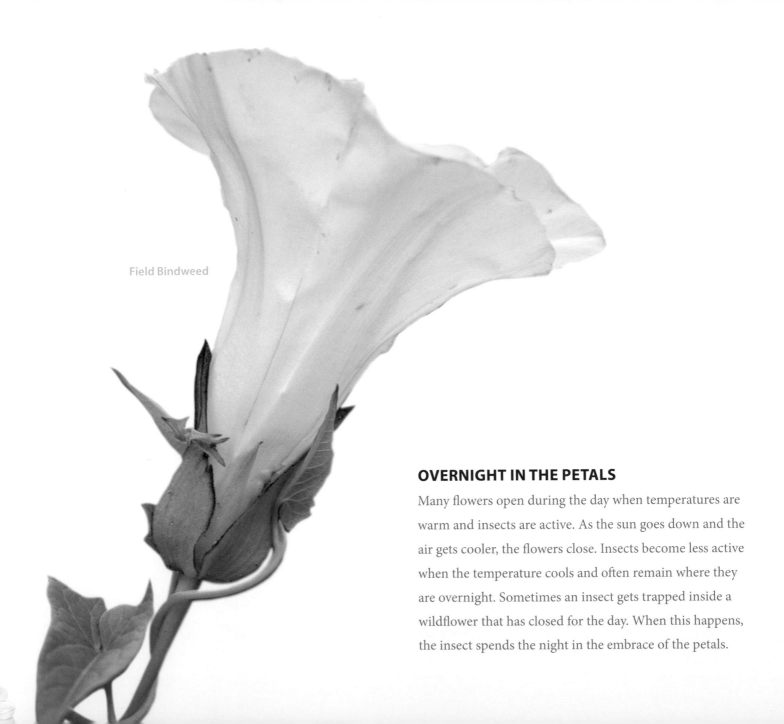

Field Bindweed

OVERNIGHT IN THE PETALS

Many flowers open during the day when temperatures are warm and insects are active. As the sun goes down and the air gets cooler, the flowers close. Insects become less active when the temperature cools and often remain where they are overnight. Sometimes an insect gets trapped inside a wildflower that has closed for the day. When this happens, the insect spends the night in the embrace of the petals.

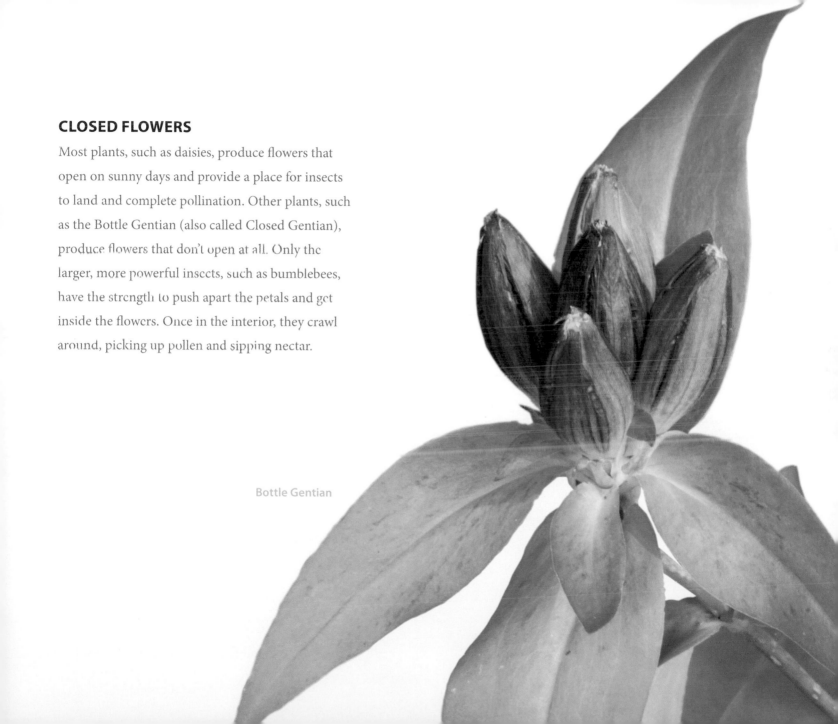

CLOSED FLOWERS

Most plants, such as daisies, produce flowers that open on sunny days and provide a place for insects to land and complete pollination. Other plants, such as the Bottle Gentian (also called Closed Gentian), produce flowers that don't open at all. Only the larger, more powerful insects, such as bumblebees, have the strength to push apart the petals and get inside the flowers. Once in the interior, they crawl around, picking up pollen and sipping nectar.

Bottle Gentian

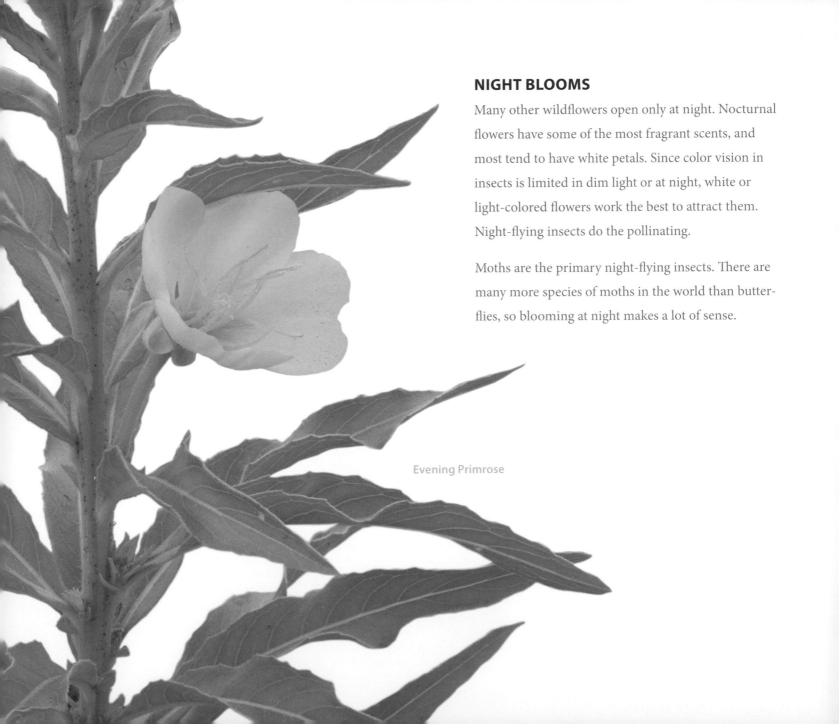

NIGHT BLOOMS

Many other wildflowers open only at night. Nocturnal flowers have some of the most fragrant scents, and most tend to have white petals. Since color vision in insects is limited in dim light or at night, white or light-colored flowers work the best to attract them. Night-flying insects do the pollinating.

Moths are the primary night-flying insects. There are many more species of moths in the world than butterflies, so blooming at night makes a lot of sense.

Evening Primrose

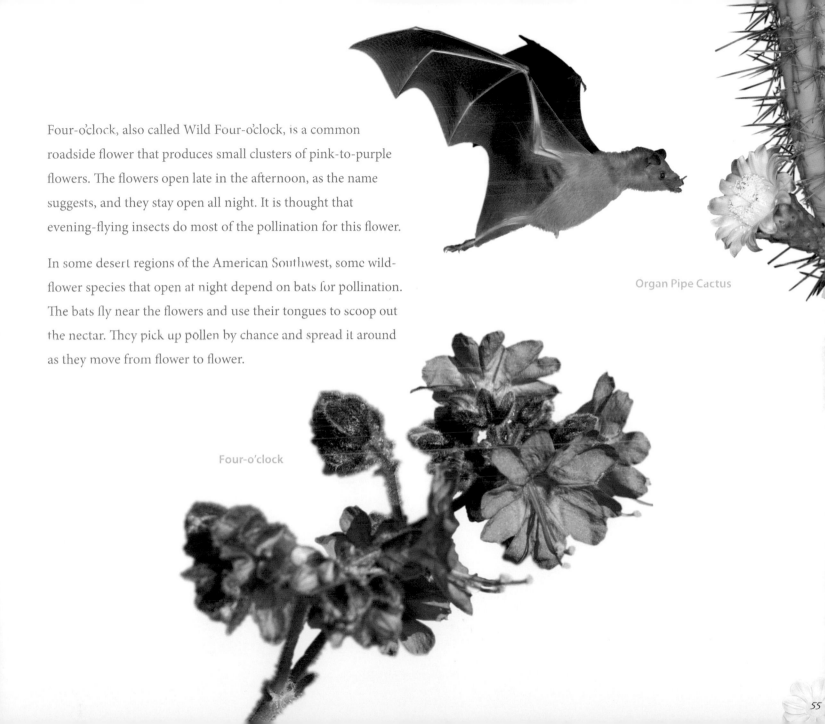

Four-o'clock, also called Wild Four-o'clock, is a common roadside flower that produces small clusters of pink-to-purple flowers. The flowers open late in the afternoon, as the name suggests, and they stay open all night. It is thought that evening-flying insects do most of the pollination for this flower.

In some desert regions of the American Southwest, some wild-flower species that open at night depend on bats for pollination. The bats fly near the flowers and use their tongues to scoop out the nectar. They pick up pollen by chance and spread it around as they move from flower to flower.

Organ Pipe Cactus

Four-o'clock

Growth and Life Cycles

Not all wildflowers grow in the same way or have the same life cycle. Instead, they all have adapted to different habitats with different conditions. For example, wildflowers in dense deciduous forests need to grow quickly and produce seeds before the tree leaves above fill in and block out the sun. Other wildflowers enjoy the sun so much that their flowers actually track the sun's movement across the sky. In contrast, the Compass Plant, a wildflower that grows in direct sunlight, must modify its growth in order to tolerate the sun's intense rays.

A number of wildflower species have evolved to rely on wildfires to renew the landscape and hold back the growth of competing plants. Other wildflowers are not wild at all, but rather are non-native plants that were introduced and are now growing in the wild.

Wood Anemone

GROWING TOWARD THE SUN

Nearly all plants grow toward the sun. On the side of the plant that faces the sun, the cells of the plant are smaller and grow more slowly than the cells on the opposite side. On the side that faces away from the sun, the cells are larger and grow more quickly than those on the other side. The combination of these features works to tilt the plant's stem toward the sun. This growth is called phototropism, or movement toward the light.

On the other end of a wildflower plant are the roots. The roots grow down, away from the sun, because they have a negative phototropism, called aphototropism.

Goat's Beard

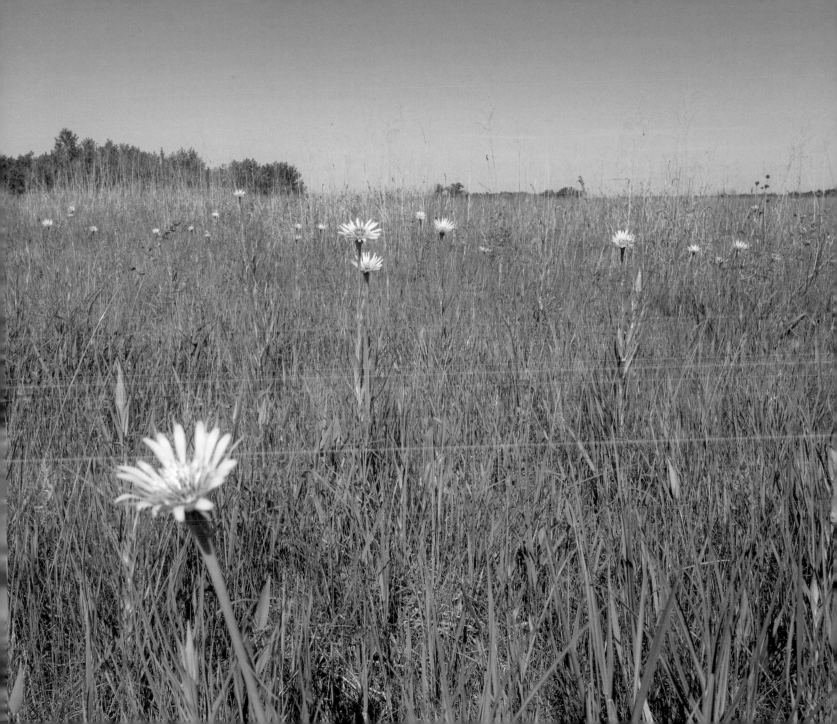

SUN-TRACKING FLOWERS

Some flowers take their relationship with the sun a step further—they follow the sun's movement across the sky. Many sunflower species do this. These flowers are called heliotropic flowers, or sun-tracking flowers. Their flower heads point toward the sun in the morning, and they slowly change position during the day to face the sun all day. Some flowers in harsh or alpine climates also do this to take advantage of the limited amount of sunlight during their short growing season.

In addition to absorbing more sunlight, flowers that track the sun provide a warmer microclimate inside the flower. This is especially attractive to insects. Whenever flowers attract more insects, it becomes more likely that successful pollination will occur.

Woodland Sunflower

COMPASS-LIKE POSITIONING

One species in the sunflower family grows in a way that shields the plant from the sun rather than facing it all day. Aptly named, the Compass Plant is known for its unique, compass-like positioning. The leaves at the base (basal) of the plant are huge, deeply divided, and tend to orient vertically in a north-south direction. In this position, the Compass Plant avoids the direct rays of the sun as it moves east-west overhead.

Compass Plant

PRAIRIE FIRE BURNS

Many of our native prairie flowers and grasses evolved over hundreds of thousands of years. Plants that grow in native prairie habitats have extremely deep roots, often more than double the length of the green part of the plant that grows aboveground. Deep roots do well at surviving the ravages of wildfires.

Prairie fires often occur in spring, when plants from the previous year are dry and brown and usually are lying on the ground. These old plants are the perfect fuel for a fire. Fires change the habitat and provide several benefits.

First, fire burns the old plants and returns the nutrients inside the leaves and stems back to the soil. This gives a shot of fertilizer to newly growing prairie plants.

Second, the newly blackened ground helps the soil absorb the rays of the sun. In spring, the sun warms the blackened soil and enables the plants to start growing at least a month earlier than other plants in areas untouched by fire. Early sprouting and growth enables native prairie plants to outcompete the non-native plants. All of our native prairie plants grow quicker, stronger and thicker after prairie fires.

Third, a fire in the prairie burns off or helps to kill invasive plants, such as raspberry shrubs and cottonwood trees. Shrubs and trees typically don't survive a hot fire, allowing for native prairie plants to grow.

Overall, a spring fire can turn out to be a good thing for our native prairies. It may look devastating at first, but in the long run, the native prairie plants benefit greatly.

Controlled burn

62

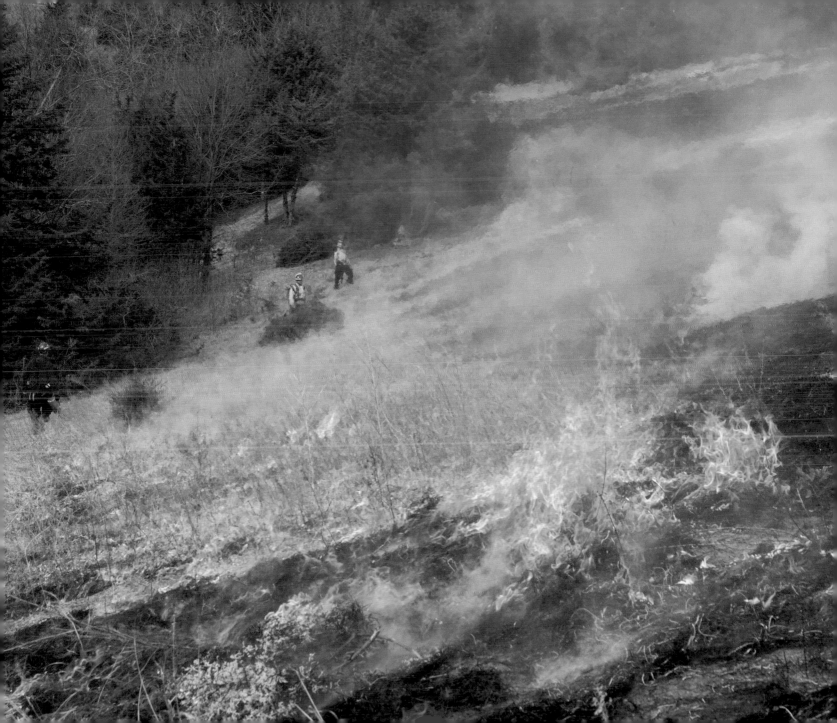

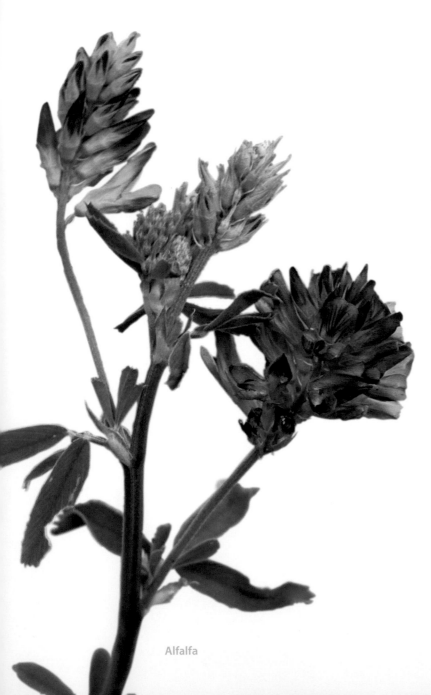
Alfalfa

NON-NATIVES AND NATIVES

Over time, and for various reasons, people have transported and planted a wide variety of wild plants from place to place around the world. The main reason to do this was for food. Dandelions and Chicory, for example, were among the edible plants that were brought to North America for their nutritional content and fast growth in gardens. When the seeds of these non-natives blew away on the wind and took root in the wild, the plants started to flourish across the land. Now, many of these species are considered weeds. In America alone, millions of gallons of herbicides are applied each year to curb their growth.

Many of these non-native wildflowers have been in North America for many hundreds of years and have become so common that they are now naturalized. Some of these, such as Garlic Mustard, grow so aggressively that they sometimes push out native woodland wildflowers. Garlic Mustard and other plants that threaten native environments are often considered invasive.

Other wildflower species were imported and planted in roadsides to stabilize the soil after road construction. Crown Vetch, Leafy Spurge and others that were purposely planted along many miles of roads have taken over and are invading large areas of natural ground. The spread of these non-natives has choked out all other plants, and they are now deemed to be invasive.

Some wildflowers were inadvertently brought to America and Canada in the form of seeds. Some seeds came mixed in animal feed. Others were caught in the trouser cuffs of immigrants. Still others stuck to shoes or lodged in the hooves of livestock that were imported. Whichever way they arrived, there is a plethora today of non-native plants with brightly colored flowers throughout the landscape. In some regions, there are large-scale programs that attempt to eradicate the non-natives. In other areas, they are still cultivated, like alfalfa, to feed livestock, or planted along roadsides.

Crown Vetch

ANNUALS, BIENNIALS AND PERENNIALS

When the growing season draws to a close and wildflowers across the country prepare for winter, the landscape changes dramatically. Herbaceous plants survive the winter and sprout successfully during spring in one of three ways: they grow annually, biennially or perennially. Each type of these plants has a different life cycle that lasts for a specific length of time.

Wildflowers that start from seed each season and grow for only one season to complete their life cycle are called annuals. Annuals must grow and produce flowers and massive amounts of seeds in one growing season, namely summer, to ensure they'll survive to sprout in the next growing season.

The ripe seeds remain dormant on the ground over winter. In spring, when the soil warms and rain moistens it, the seeds of annuals sprout and start a new generation of wildflowers. This process is repeated in each growing season. Jewelweed is a good example of an annual wildflower. It grows in the same damp soil conditions year after year from seed.

Other wildflowers, such as the Common Mullein, are biennial plants that take two years to complete their life cycle. A biennial plant starts as a seed and produces one low-growing rosette, or collection of leaves, called basal leaves, for the first year of life. The leaves use the sun to make energy, which is stored in the roots. In the second year of its life, the plant produces basal leaves and also sends up a stalk for flowering and reproducing with seeds. After the second growing season, the plant dies, leaving the seeds to restart the cycle once again.

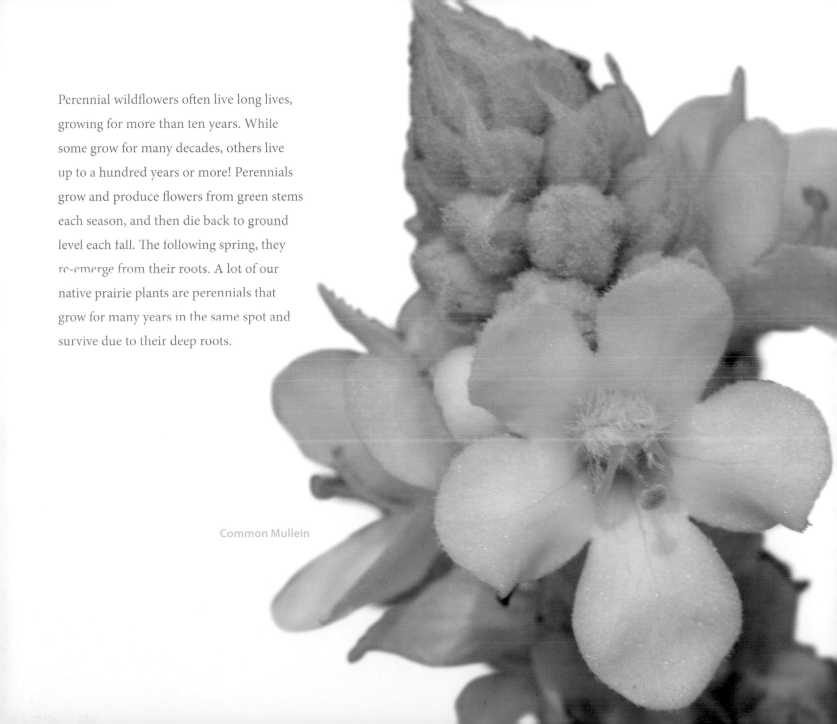

Perennial wildflowers often live long lives, growing for more than ten years. While some grow for many decades, others live up to a hundred years or more! Perennials grow and produce flowers from green stems each season, and then die back to ground level each fall. The following spring, they re-emerge from their roots. A lot of our native prairie plants are perennials that grow for many years in the same spot and survive due to their deep roots.

Common Mullein

Woodland wildflowers

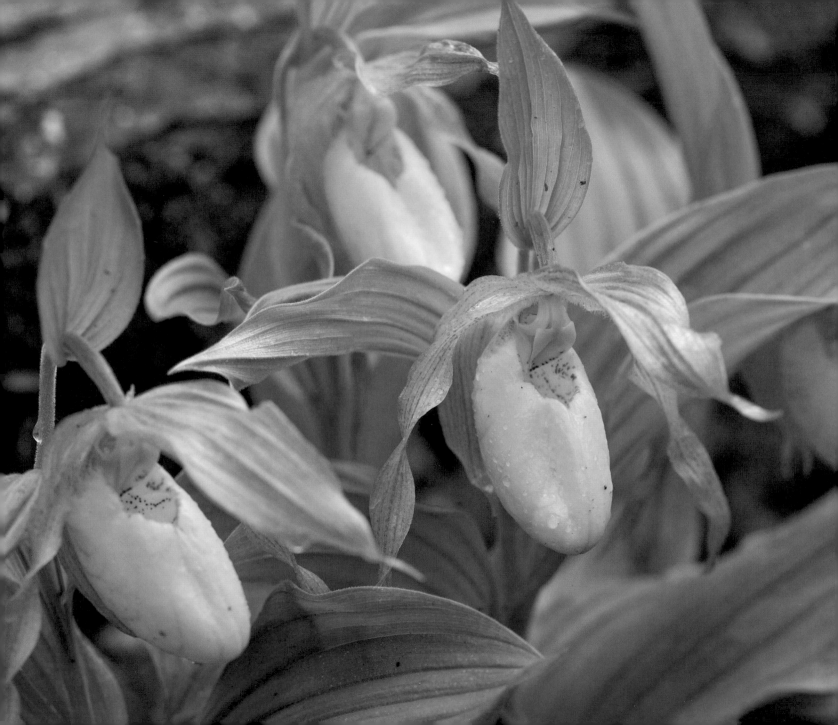

The Orchids

Orchids are prized wildflowers and highly specialized plants. According to fossil evidence, orchids have been thriving on the planet for over 100 million years! Today, the orchid family is one of the largest groups of flowering plants in the world, with almost 30,000 species. Some of the best-known orchids are the lady's slippers.

Every orchid species has a unique and interesting flower. The blooms can be as small as a penny or as large as a baked potato. One type of orchid that grows in the tropics produces the seedpod from which we get vanilla. Other orchid species can live upwards of 100 years. Orchids can be as varied as they are unique.

Yellow Lady's Slipper

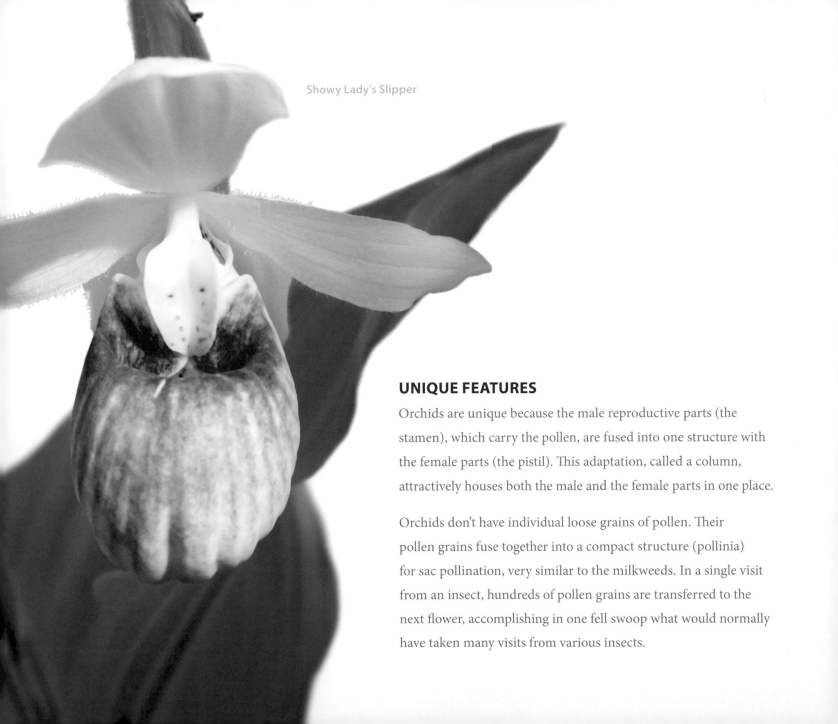

Showy Lady's Slipper

UNIQUE FEATURES

Orchids are unique because the male reproductive parts (the stamen), which carry the pollen, are fused into one structure with the female parts (the pistil). This adaptation, called a column, attractively houses both the male and the female parts in one place.

Orchids don't have individual loose grains of pollen. Their pollen grains fuse together into a compact structure (pollinia) for sac pollination, very similar to the milkweeds. In a single visit from an insect, hundreds of pollen grains are transferred to the next flower, accomplishing in one fell swoop what would normally have taken many visits from various insects.

After pollination, an orchid's ovary swells, forming a seed capsule filled with hundreds of thousands, and in some species, millions, of microscopic seeds. Unlike other plants, the seeds of orchids aren't dropped on the ground or carried off by insects or birds. The minute orchid seeds are so tiny that they drift off on the wind for dissemination instead.

A seed will only have a chance to grow if it lands on suitable soil. However, this is just part of the story. Orchid seeds lack the nutrients needed for germination (endosperm), but they do have a special association with fungi (mycorrhiza) in the soil. These fungi allow the seeds to absorb water and a few nutrients, which enables the seeds to sprout and grow.

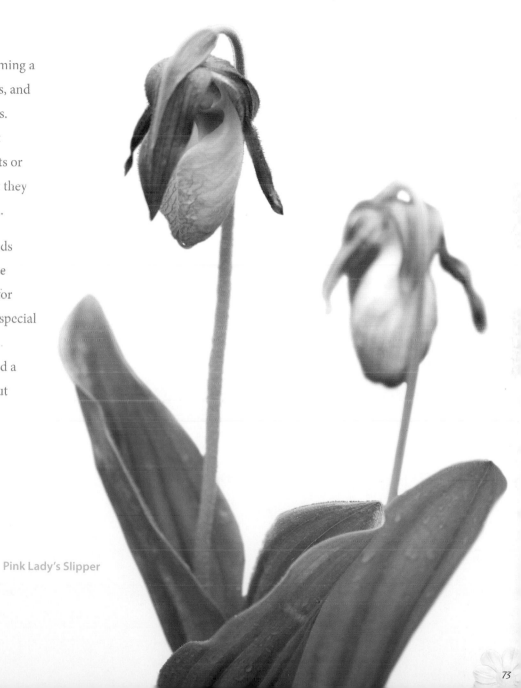

Pink Lady's Slipper

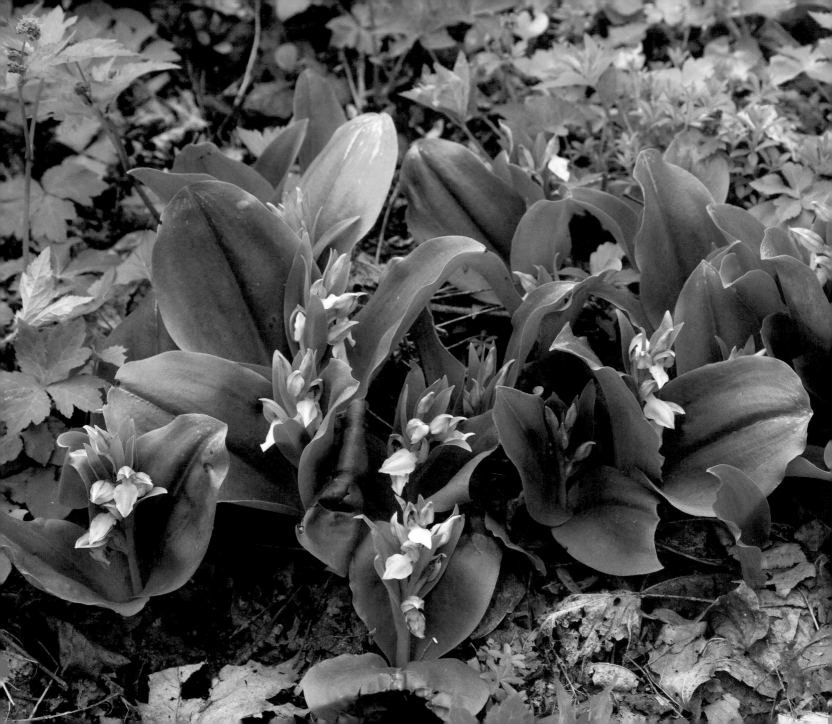

It's mainly insects that pollinate orchids, but some orchid species are so highly specialized that only one insect species can do the job. Other orchids have more insect species that are capable of pollinating. Specialization ensures that direct transfer of pollen takes place. This reduces the chances that pollen will be dropped or lost.

Many orchid species don't rely on random insect visitations for pollination. Instead, they use deception to attract pollinators, usually by physical mimicry or chemical attractants. Some orchids look like or smell like they offer food but offer no edible reward to visiting insects. Other orchids use both ploys at the same time.

Sometimes an orchid flower resembles the female of an insect species (such as a particular beetle). When the male beetle investigates the "female," a pollinia sac attaches to him, and he eventually carries it off to the next orchid flower.

Some orchids release a chemical compound that mimics the attractant pheromones of a specific insect species. When an insect of that species comes to investigate, it inadvertently picks up a pollinia sac. When the insect visits another orchid flower, the pollen is transferred and pollination is complete.

Each spring, a special orchid dots the forest floor. The Showy Orchis has a pink hood and a white tongue, or lip. The lip serves as a landing platform for pollinating insects, but they need to push hard to get inside this flower. The flowers have a pleasant fragrance and grow in ones and twos, and sometimes up to 20 or more per plant. The plant can be erratic in its presence. It might bloom in one spot for a number of years, and then seem to disappear. Chances are it will show up in another spot a short distance away.

Showy Orchis

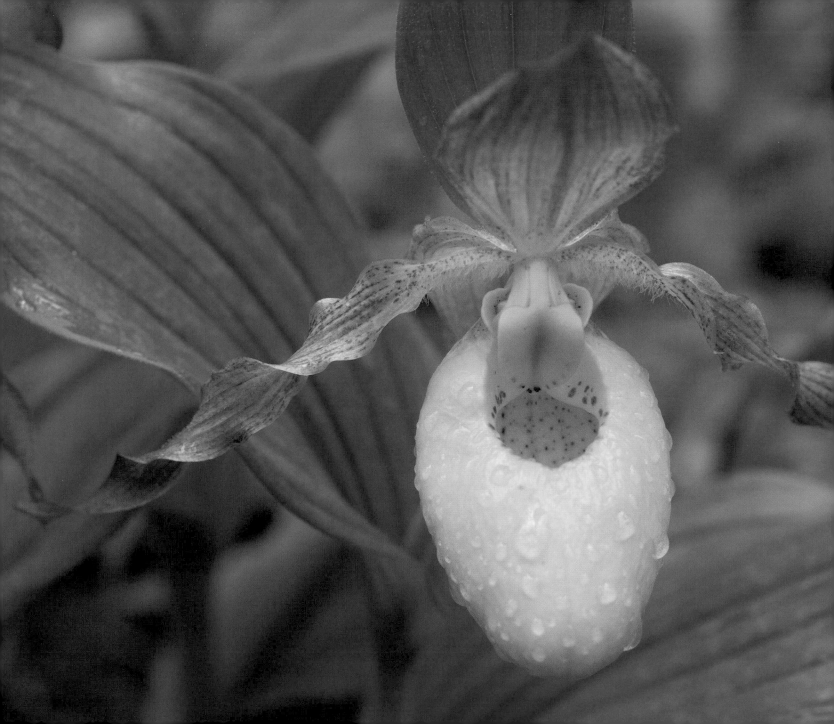

THE LADY'S SLIPPERS

The lady's slippers are some of the most spectacular orchids. All species in the United States and Canada are in the genus *Cypripedium*. The genus name derives from "Cypris," the Latin name for the goddess Venus at Cyprus, and *pedilon*, Greek for "sandal."

There are about 50 species of lady's slippers in the boreal, temperate and tropical regions of the world. We are fortunate to have a number of these in North America. One of the more common is the Yellow Lady's Slipper. It often grows in large clumps in deep, moist woods.

A special feature that makes lady's slippers unique is the fusion of their lower petals. These petals are fused to form an air-filled pouch, called the labellum.

Yellow Lady's Slipper

Pollination of a lady's slipper begins when an insect lands on the labellum, or the "front porch," of the flower and enters through a small hole. As it makes its way around the inside of the flower, it picks up pollen or deposits it, completing fertilization. Unable to back out, the insect exits out the back or bottom, or the "back door," of the flower.

Like other orchids, lady's slippers require a special fungus to grow on their roots in order to survive. The lack of fungus growth on their roots is the primary reason why many wild lady's slippers that are illegally dug up end up dead after transplanting.

In the northeastern and north central parts of the United States and Canada, a large multi-stemmed orchid grows in moist, deciduous forests. The Showy Lady's Slipper can stand over two feet tall and produces amazing pink-and-white flowers. It is listed as vulnerable, threatened or endangered in most states and Canada and is the official state flower of Minnesota.

Showy Lady's Slipper

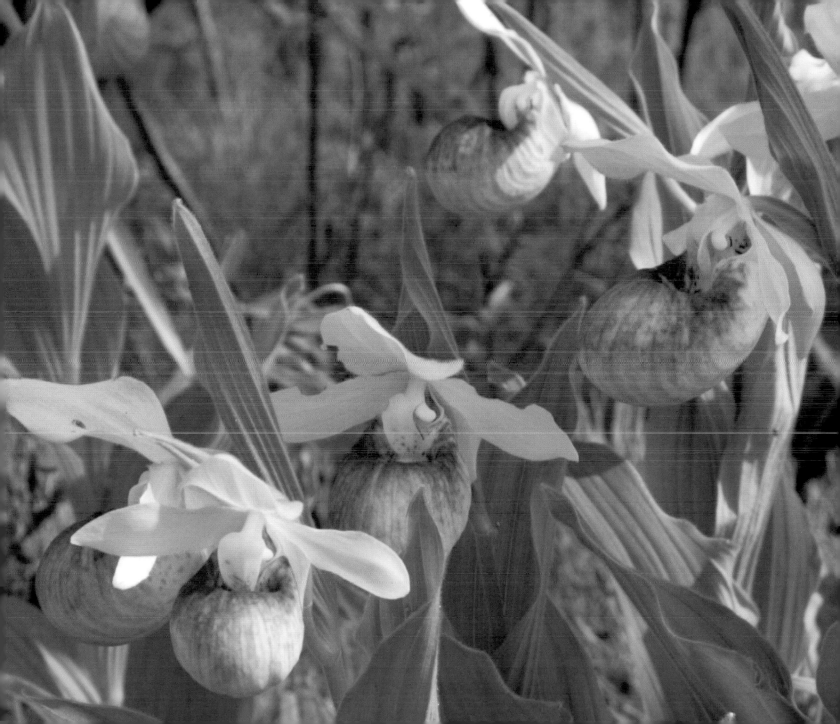

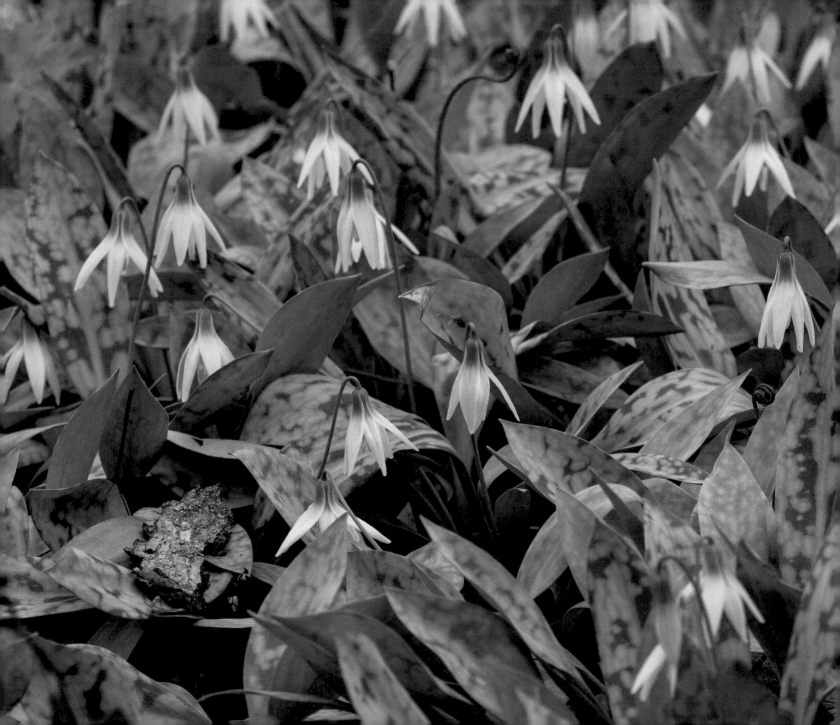

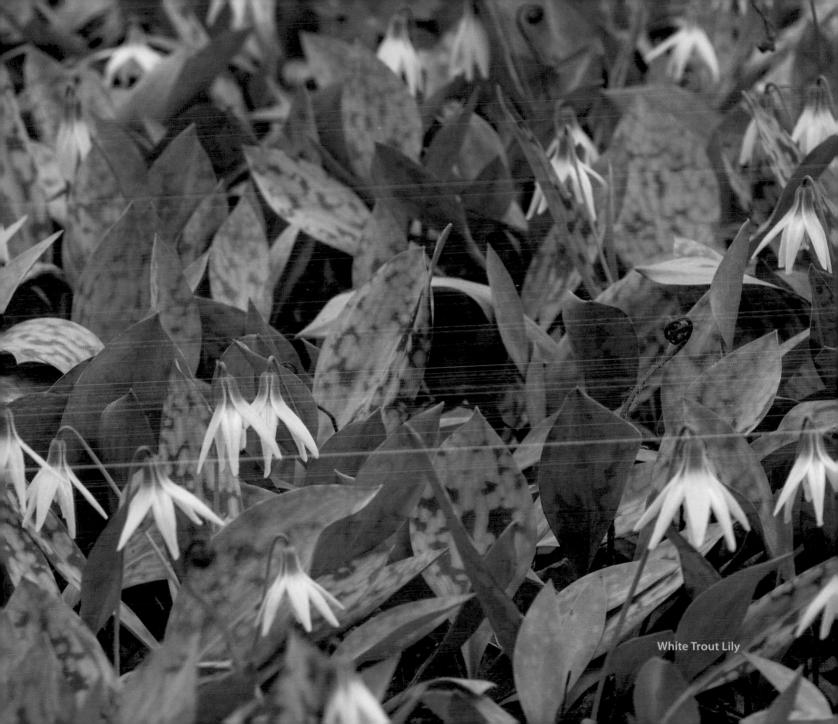

White Trout Lily

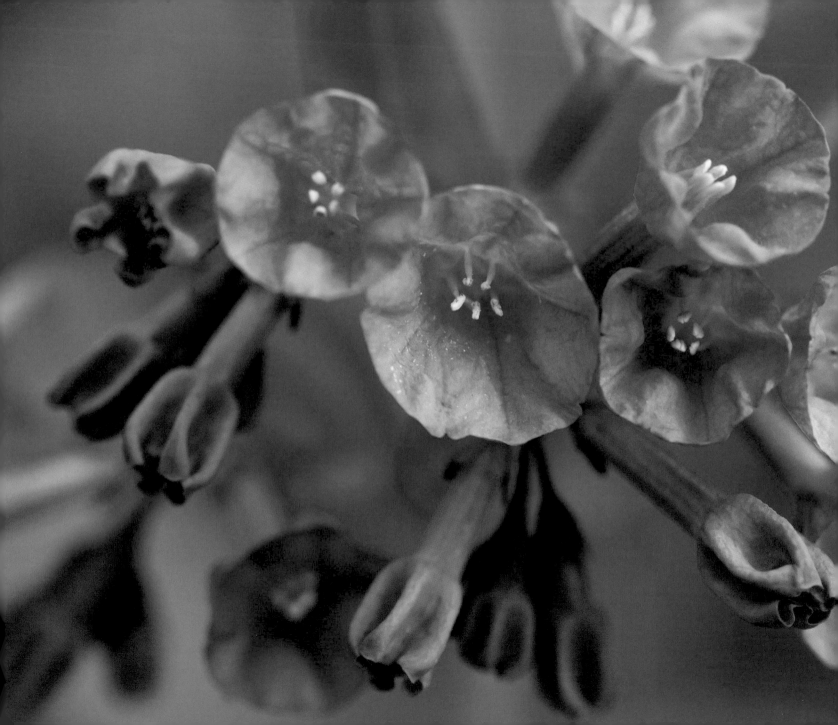

Spring Wildflowers

Spring is the best time for wildflowers in the woodlands of North America. As the earth wakes from its winter dormancy, wildflowers grow deep in the woods. They grow in deciduous forests under a canopy of tall, mature trees, and they are the first plants to appear. These wildflowers are called spring ephemerals.

Some of our most spectacular-looking wildflowers, such as the Virginia Bluebells, Snow Trillium and Bloodroot, are spring ephemerals. Ephemerals must sprout, grow, produce flowers and become pollinated before the branches above produce leaves and shade. The entire life cycle of these wildflowers takes place before the trees shade the forest floor. When ephemerals die back to the ground, they won't be seen again until early next spring.

Virginia Bluebells

THE TROUT LILIES

Trout lilies get their common name from the patterns on their leaves, which resemble the mottled look of brook trout. Members of the lily family, trout lilies send up delicate yellow or white flowers. Insects will pollinate the flowers, but the plant doesn't depend on the insects for reproduction. Instead, the majority of the reproduction is accomplished via underground cloning.

Trout lilies have small underground bulbs that replicate themselves repeatedly to reproduce. The replication rate is why you usually won't see these plants growing in ones and twos. Normally trout lily plants grow in patches that can spread to produce large carpets of flowers. Genetically, all trout lily plants in a species, such as the Yellow Trout Lily and White Trout Lily, are identical. They are clones of an original plant that has reproduced over and over again.

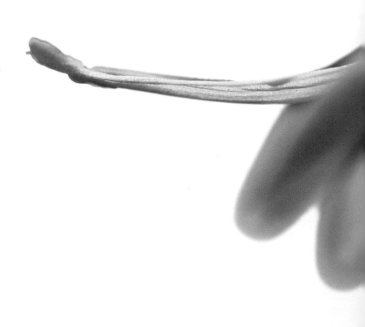

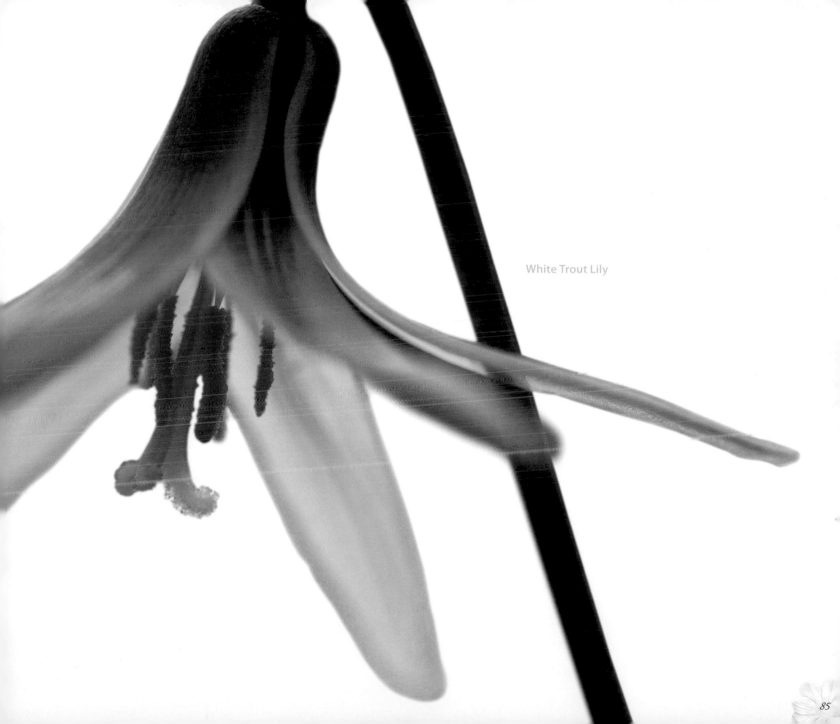

White Trout Lily

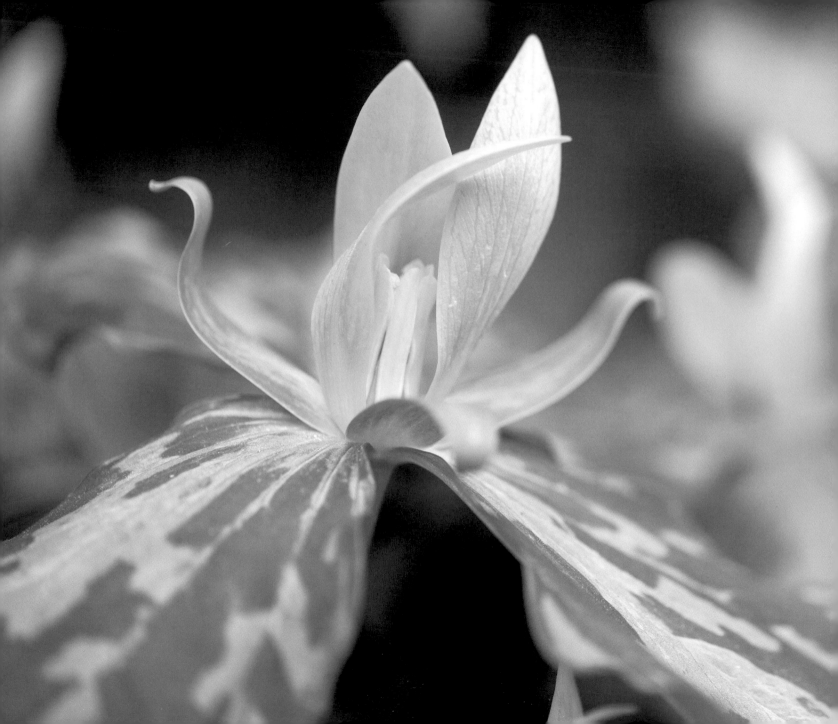

THE TRILLIUMS

Trilliums are a favorite wildflower. There are many different kinds of trilliums, but in all species, each of the leaves, the petals and the sepals grow in groups of three. In fact, the genus name *Trillium* originates from the Latin word *trēs*, meaning "three."

The Yellow Trillium, also called Yellow Wakerobin, is one of our beloved spring wildflowers. The Great Smoky Mountains are well known for the bloom of this magnificent flower in spring. It grows in the mature deciduous forests of Kentucky, Tennessee, North Carolina and Georgia.

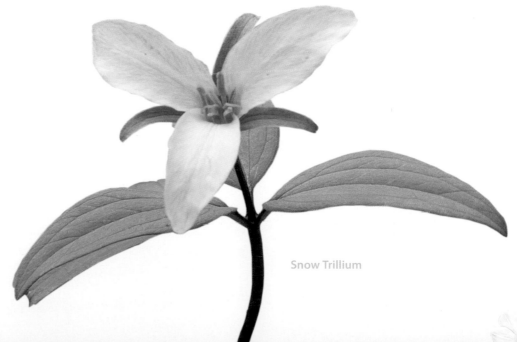

Snow Trillium

Yellow Trillium

The Large-flowered Trillium sometimes grows in large carpets, occasionally covering the entire woodland floor. As the name suggests, it produces a large flower. Three white petals with three pointed sepals stand above a whorl of three leaves. For three or four weeks, these trilliums grow under tall trees in the early dappled spring sunshine. As the season progresses, the white flowers change to beautiful shades of pink before the petals drop.

One of the more uncommon trilliums is the Painted Trillium. Growing in small groups on the forest floor, the red interior of the blooms is a real eye-catcher.

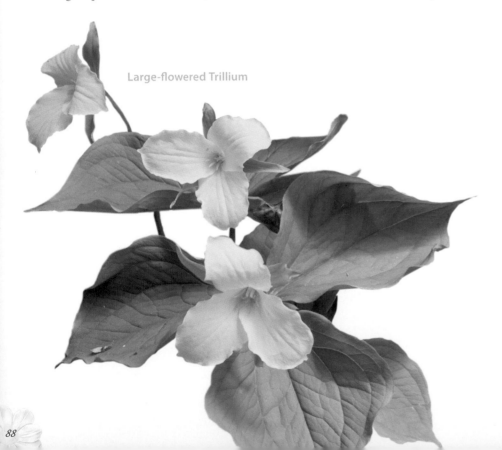

Large-flowered Trillium

Painted Trillium

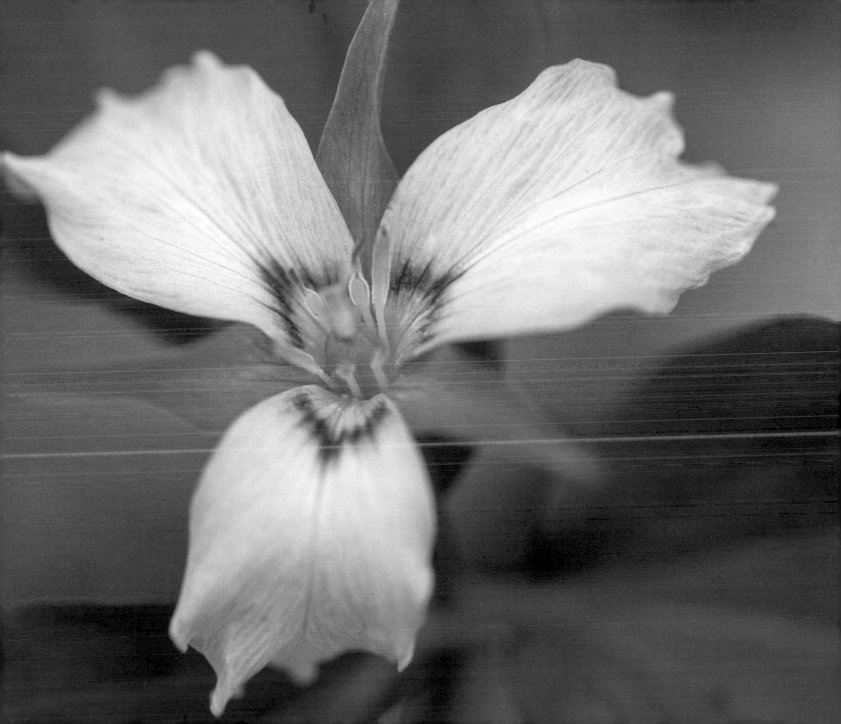

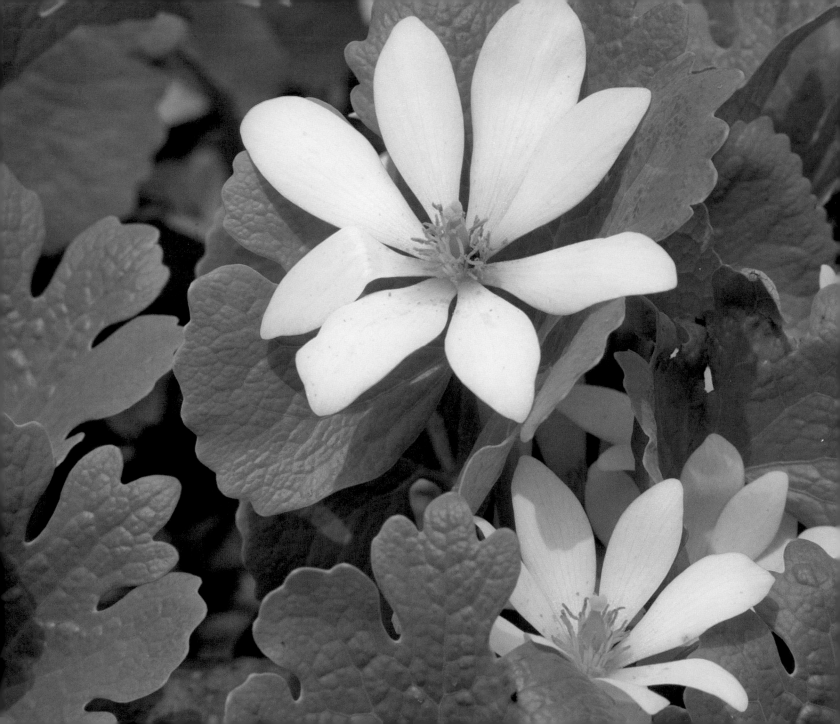

BLOODROOT

Bloodroot is one of the first ephemerals to bloom, emerging from nearly frozen soils. A large multilobed leaf appears, followed quickly by a flower. The leaf stays partly rolled, clasping around the stem and flower. When the flower opens, the leaf surrounds the petals and provides protection against the chilly winds of spring. As the sun warms the flower, the large leaf retains the warmth and produces a microenvironment that is attractive to small flying insects. These insects take refuge between the leaf and the flower.

The Bloodroot flower opens wide on sunny days and remains tightly closed on cloudy days. All parts of the plant contain an orange-to-red juice. This colorful juice was used by many cultures as a dye and an insect repellent, and gives the plant its name.

After the flower is pollinated, the petals quickly fall off and the leaf flattens out to soak up as much sunlight as possible. In just a matter of a few weeks, the seedpod ripens to a light tan capsule and the entire plant dies back to the ground.

Bloodroot

Bloodroot

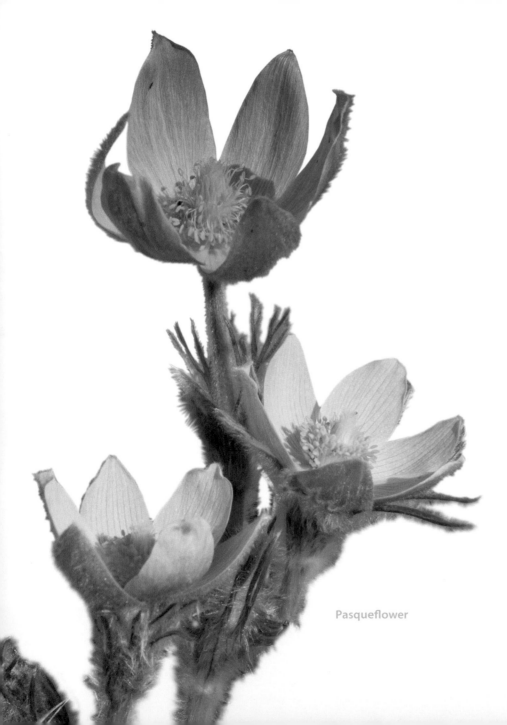

Pasqueflower

PASQUEFLOWER

Some wildflower plants, such as the Pasqueflower, are covered with a thick, woolly coat of hairs. This early ephemeral often flowers while snow is still on the ground. Soft, silvery hairs cover the plant entirely, like a winter jacket, trapping warm air heated by the sun. Flying insects enter the warm microenvironment and pollinate the plant. This flower was given the name "Pasque" for its early blooming time, around Easter or Pasch (Passover).

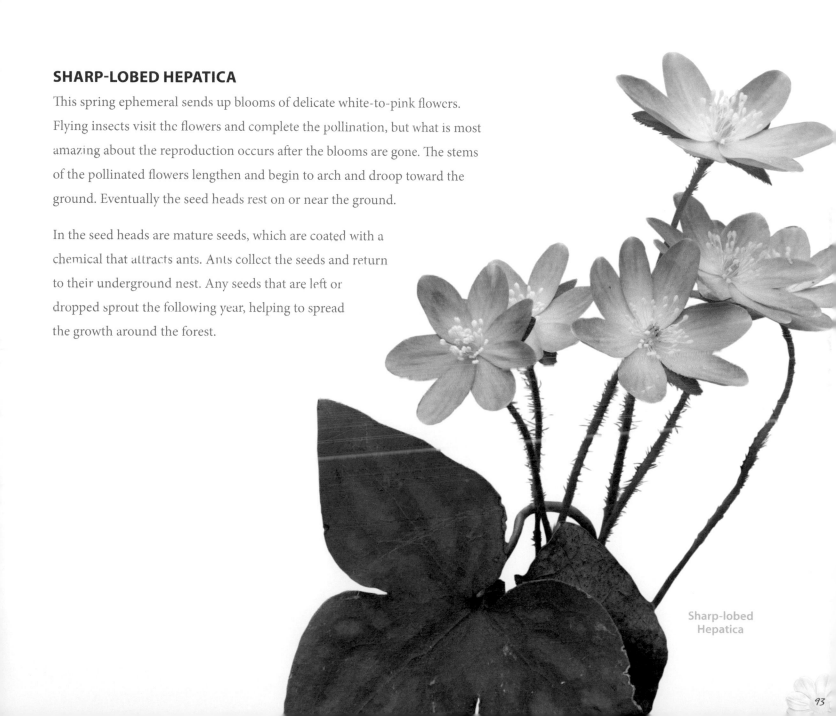

SHARP-LOBED HEPATICA

This spring ephemeral sends up blooms of delicate white-to-pink flowers. Flying insects visit the flowers and complete the pollination, but what is most amazing about the reproduction occurs after the blooms are gone. The stems of the pollinated flowers lengthen and begin to arch and droop toward the ground. Eventually the seed heads rest on or near the ground.

In the seed heads are mature seeds, which are coated with a chemical that attracts ants. Ants collect the seeds and return to their underground nest. Any seeds that are left or dropped sprout the following year, helping to spread the growth around the forest.

Sharp-lobed
Hepatica

SPRING BEAUTY

Early in spring, when the air is still cool and the sun bathes the forest floor, the Spring Beauty blooms. This is a very delicate and wonderful ephemeral. A single pair of leaves supports (subtends) a small cluster of white flowers, each only a half-inch wide. Each flower has thin pink veins that add shades of pink (sometimes purple) to the petals. The flowers open wide on sunny days, but they close and nod downward on cloudy days and at night. Some plants may have some extra-long leaves, up to six inches, growing from the base.

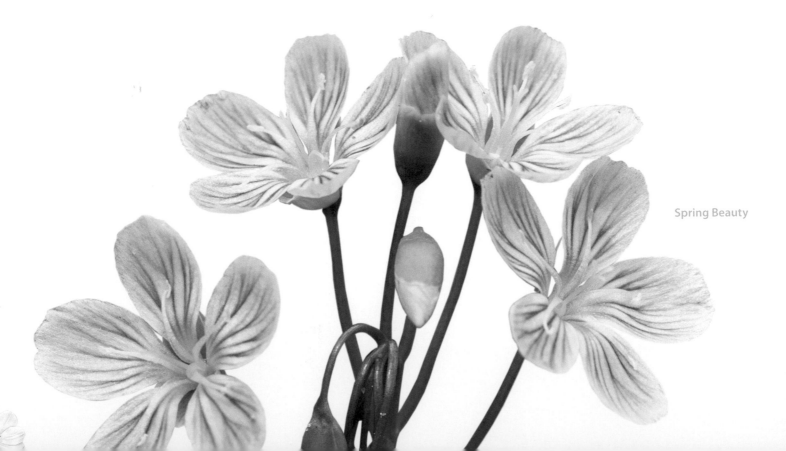

Spring Beauty

COMMON BLUE VIOLET

The Common Blue Violet is perhaps one of the most common spring wildflowers in the eastern United States and Canada. Found in nearly any habitat, from lawns and gardens to prairies and forests, this short-stemmed perennial plant is always a delight to see. Each blue-to-purple flower rises on its own stem. The flower color ranges widely from white to purple and everything in between.

The small heart-shaped leaves and blue flowers historically have been used for food and medicine. Wildlife, such as Wild Turkeys, rabbits and deer, love to eat this plant. After it is eaten, it quickly grows back.

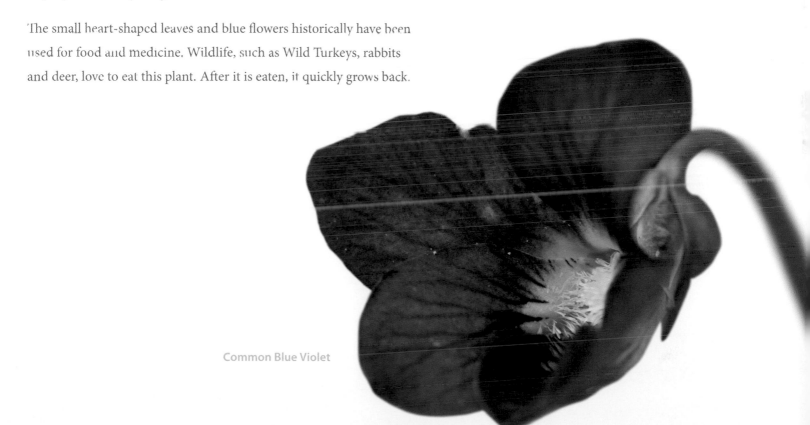

Common Blue Violet

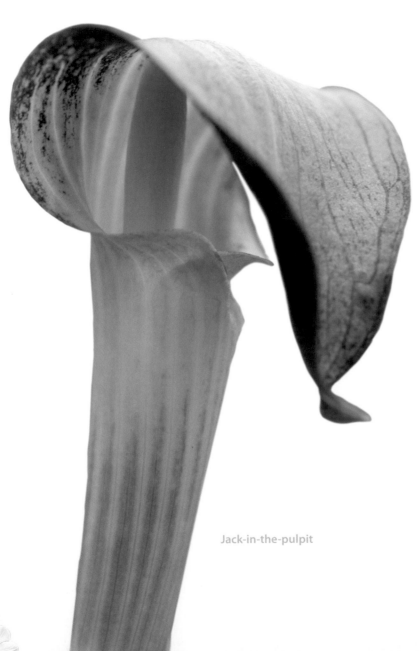

Jack-in-the-pulpit

JACK-IN-THE-PULPIT

One of the more unusual-looking spring wildflowers is the Jack-in-the-pulpit. Sometimes called Indian Turnip, this shade-loving plant grows in rich, moist, deciduous forests and floodplains. It has one or two large glossy leaves that divide into three distinct leaves, called leaflets. This form is called trifoliate.

The three-part leaflets are often confused with a trillium's whorl of three leaves or with poison ivy, but it's easy to tell them apart by looking at the veins. Jack-in-the-pulpit veins run close to the edge (margin) of the leaflets and completely encircle them without ever reaching the edge.

This plant has a very distinctive flower growing beneath the leaflets. The flower has a club-shaped green structure, called a spadix, which is covered by a striped green (sometimes maroon) spathe, or leaf hood. It is always described as "Jack" sitting inside his "pulpit." To see the flower's club, you need to unfold the leaf hood.

Flying insects pollinate the flower. Later, a cone-shaped cluster of bright red berries grows. Both the berries and leaves of this plant contain calcium oxalate crystals. These are bitter and cause a burning sensation if tasted.

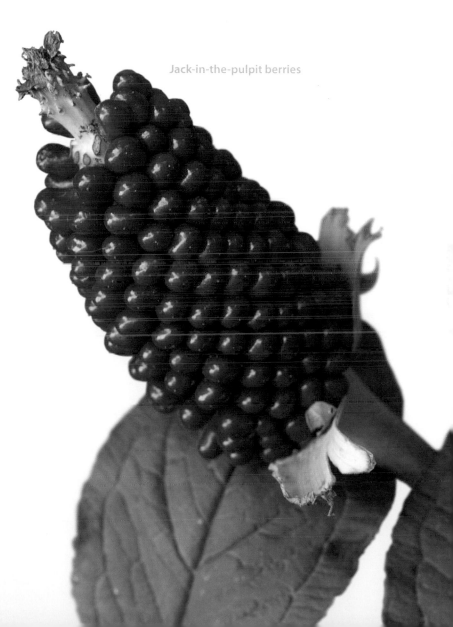

Jack-in-the-pulpit berries

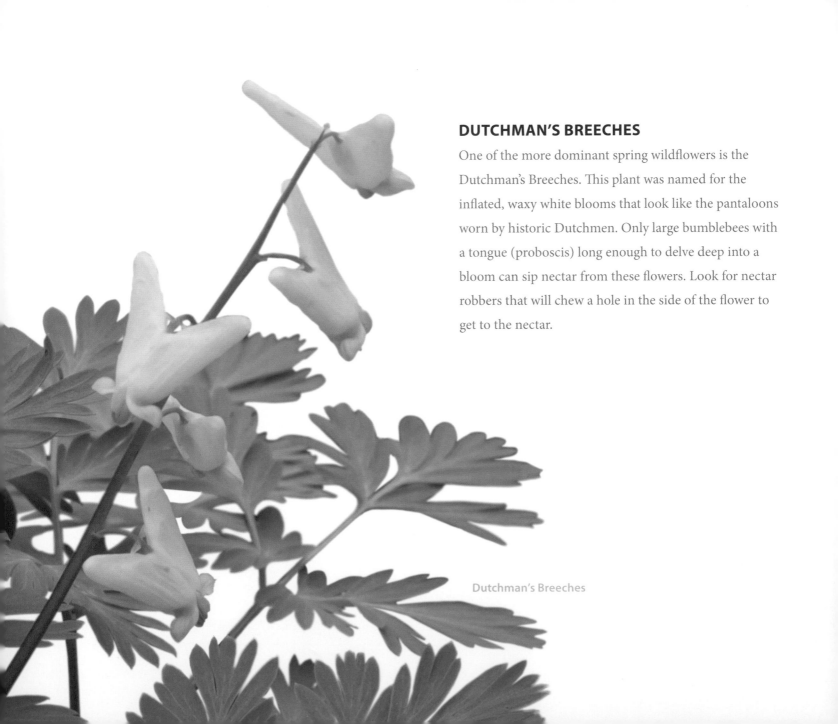

DUTCHMAN'S BREECHES

One of the more dominant spring wildflowers is the Dutchman's Breeches. This plant was named for the inflated, waxy white blooms that look like the pantaloons worn by historic Dutchmen. Only large bumblebees with a tongue (proboscis) long enough to delve deep into a bloom can sip nectar from these flowers. Look for nectar robbers that will chew a hole in the side of the flower to get to the nectar.

Dutchman's Breeches

FIRE PINK

There are few flowers that match the brilliant scarlet or crimson of the Fire Pink. Although the flowers may not be large, they stand out in any landscape. The five petals are all notched at the tip, and the stems are covered with sticky hairs.

This wildflower occurs across the eastern half of the United States and Canada, but it's relatively uncommon in most places. It is usually only found in rich, moist woodlands with rocky slopes. Fire Pink often grows with other wildflowers, which serve to highlight its red blooms.

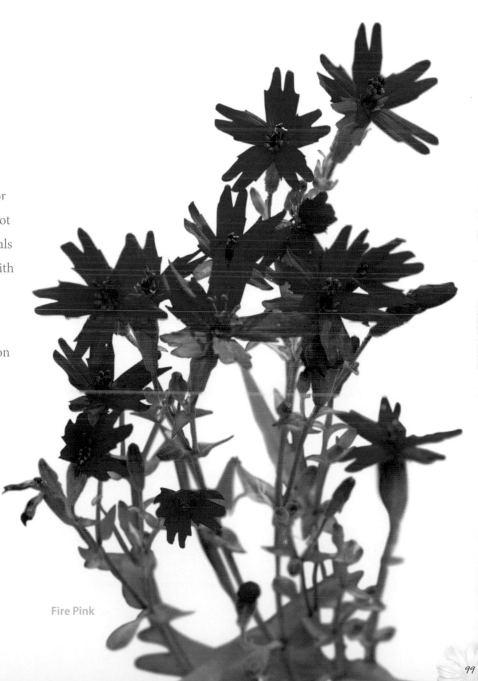

Fire Pink

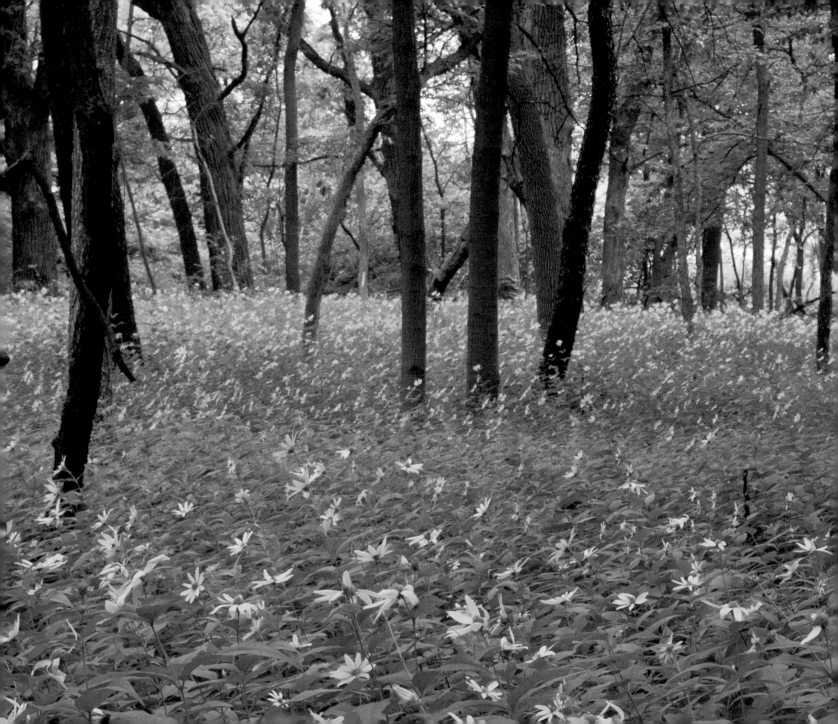

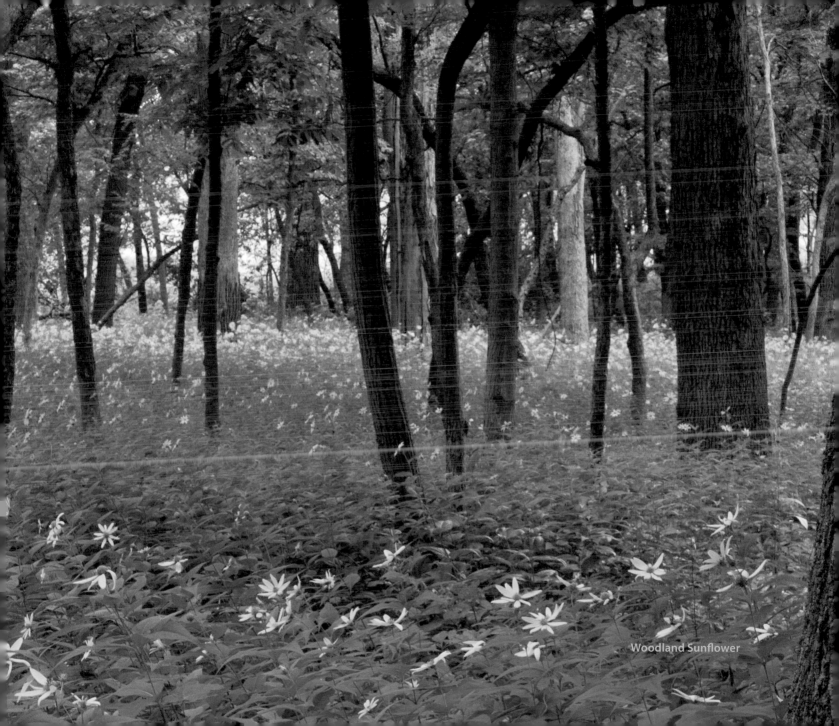
Woodland Sunflower

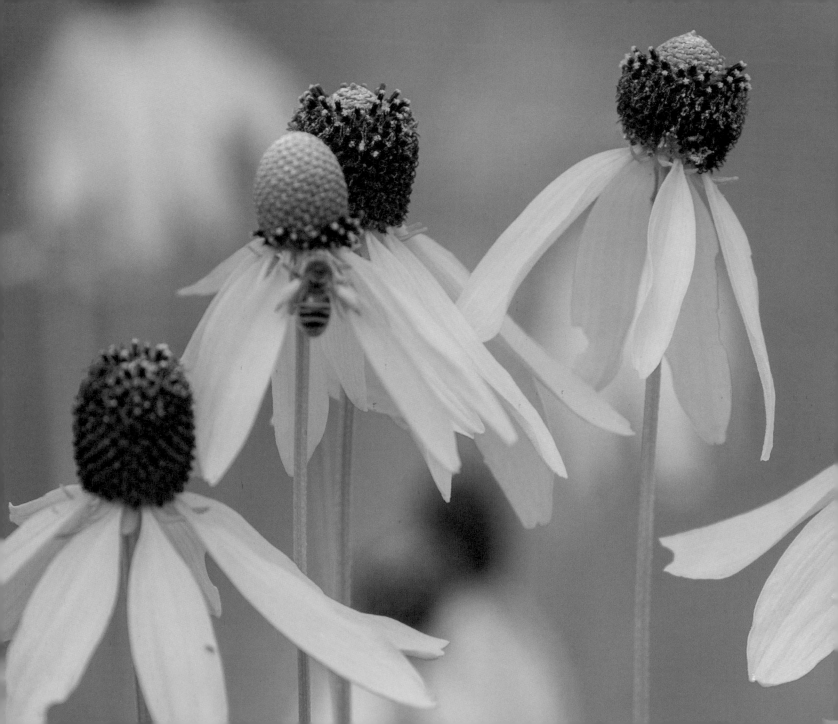

Summer Wildflowers

Summer is the season when a profusion of wildflowers fills North America's fields, prairies and mountains. Once the woodland ephemerals have decreased, the summer wildflowers burst out across the land.

Hundreds of unique and brightly colored flowers bloom in the summer. Some open as tiny individuals. Others grow in large groups. Whether single or clustered, summer flowers are often real showstoppers!

Summer-blooming wildflowers last longer than spring ephemerals and tend to be more resistant to heat and drought. Many of the plants grow right out in the open, in the direct rays of the sun. Most depend on the multitudes of summer insects for pollination.

Gray-headed
Coneflower

THE PURPLE CONEFLOWERS

Purple coneflowers are quintessential summer wildflowers. There are at least nine different species of Purple Coneflower, but they all look somewhat similar. Many cultivated varieties also exist. Members of the daisy family, coneflowers are popular plants that are often planted in gardens.

Standing tall and looking regal, these wildflowers are well-known members of the tallgrass prairie ecosystem. They are exceedingly common in the eastern and central parts of the United States and Canada.

Purple Coneflowers have a dark reddish center (disk flowers) surrounded by light purple petals (ray flowers). The arrangement of a central disk surrounded by large petals is a very common composite flower configuration.

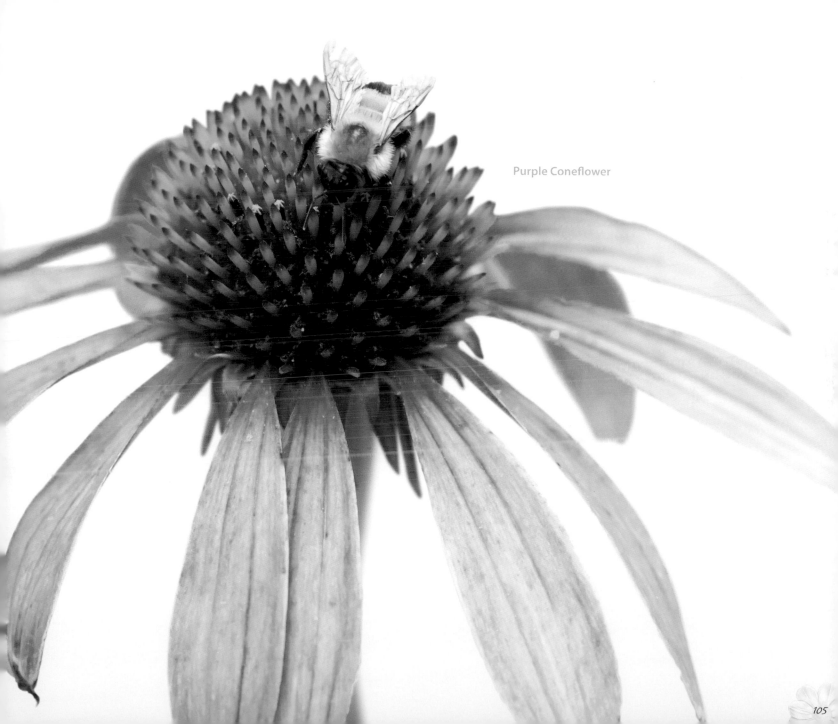

Purple Coneflower

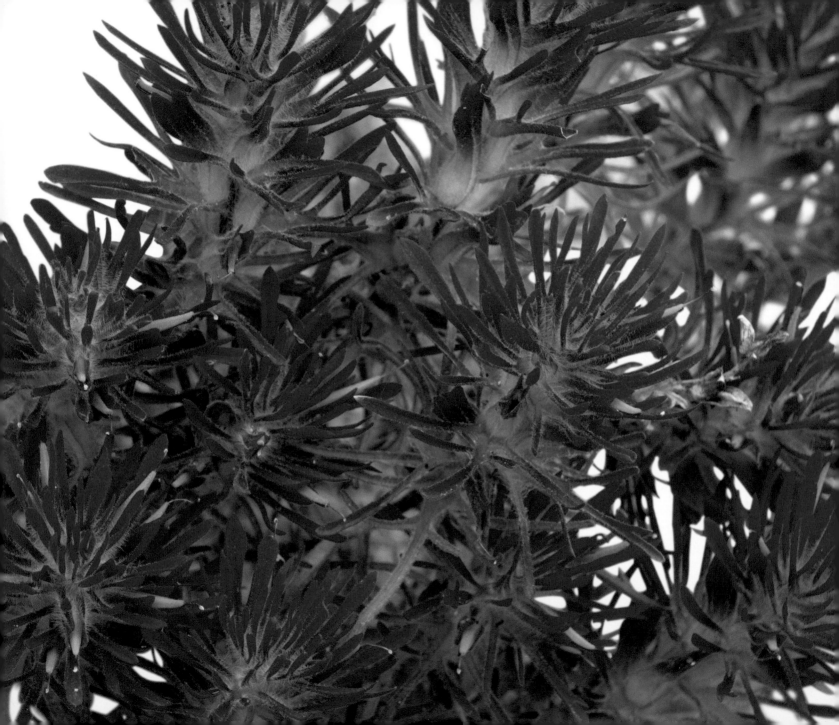

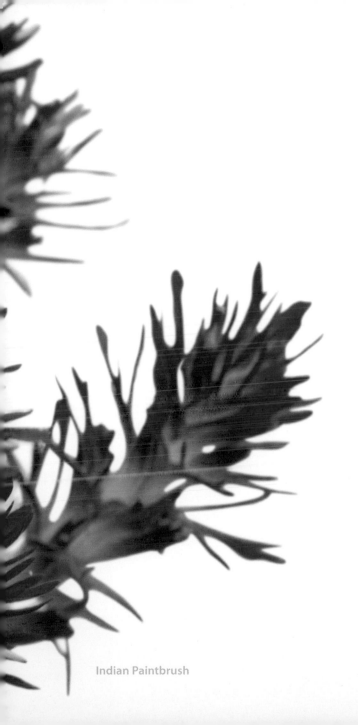

Indian Paintbrush

THE PAINTBRUSHES

Paintbrush wildflowers, such as the Indian Paintbrush, are fantastic flowers that grow in prairies or on mountaintops. About 200 paint-brush species are found in the western United States and Canada, from Alaska to Mexico.

Paintbrush plants have very attractive flowers with unique blooms. The showy red or orange parts are actually not the petals, but rather a leafy bract that surrounds the inconspicuous flower parts. In some species, the bract is yellow or pink.

Not only do paintbrushes look different from other wildflowers, but most also grow differently. Typically, they are semiparasitic green plants. Although they have chlorophyll and produce energy via photosynthesis, they also have the ability to get nutrients from other organisms in the soil, pulling vital nutrients away from other plants. They are biennial plants, so you may not see them growing in the same spot every year.

Seeds are produced in a two-chamber capsule that splits open when ripe. The wind helps scatter the seeds, but they'll stay dormant until the next spring. At that time, they will germinate and produce a small rosette of leaves. The flower stalk won't grow until the second year of life.

THE BLAZING STARS

The blazing star flower stalk stands out like a bolt of lightning in a prairie landscape. Sometimes called Gayfeather or Liatris, blazing stars grow in dry soils and full sun, but they also do well in moist soils. There are many different species, but they all look similar with only slight variations in the flowers.

The Prairie Blazing Star has several tall, narrow spikes of purple flowers that attract butterflies, hummingbirds and bees. It's not uncommon to see three or four butterflies visiting the flowers of one plant at the same time. The flowers open from the top down, not from the bottom up, like most other flowers. The flower spikes can grow upwards of five feet in some parts of the United States and Canada. It has been widely cultivated and grown in gardens, where it can reach a height of six feet.

This very popular native plant grows from underground roots, called a corm. The corm looks like a round tuber with several plant stems sprouting from the top. The corm stores food for the following year's growth and also produces new shoots to form new plants.

Blazing Star

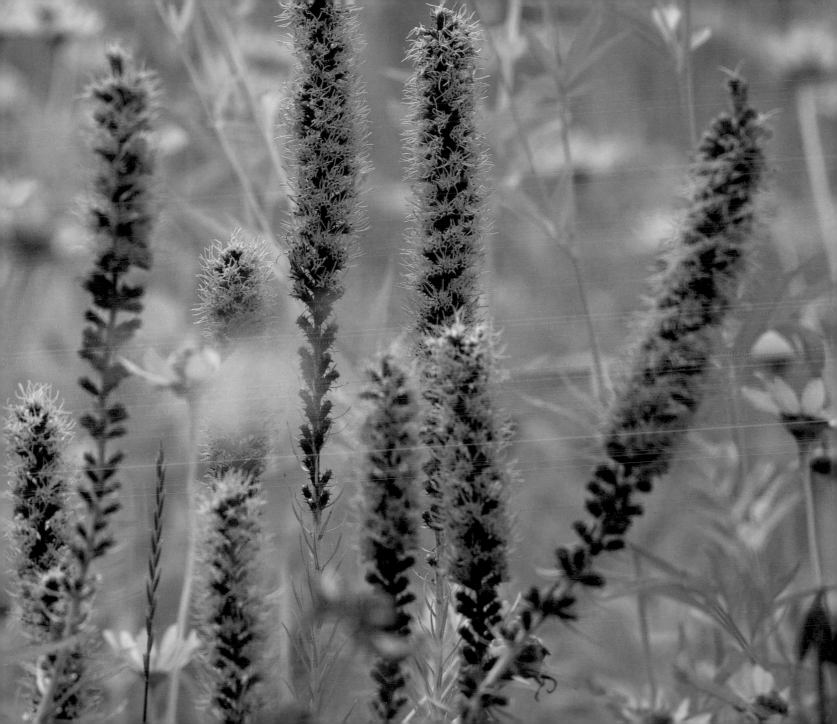

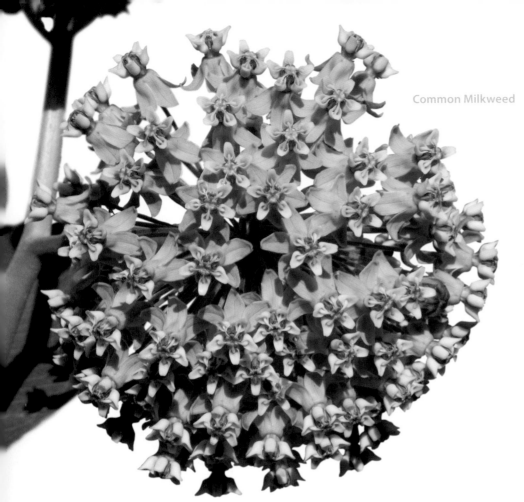
Common Milkweed

COMMON MILKWEED

The Common Milkweed is often just called Milkweed. This tall, conspicuous plant is often seen growing in clusters along roads and in open fields. During summer it puts on a showy display of large round balls of pink-to-purplish flowers. It has a mild and pleasant odor to attract insects.

Milkweed gets its name from the milky white sap found throughout the plant. This sap contains toxins known as glycosides, which affect cardiac function in many animals. Glycosides can cause a rapid heartbeat, a flushed feeling and nausea in people, so do not ingest any part of any milkweed species.

Female Monarch butterflies only lay their eggs on milkweeds. Young Monarch caterpillars hatch and eat the milkweeds without harm from the glycosides. Later, the glycosides that the caterpillars ingested make the butterflies mildly toxic to birds. In any case, this is a wonderful summer wildflower that is essential in the life cycle of our beloved Monarchs.

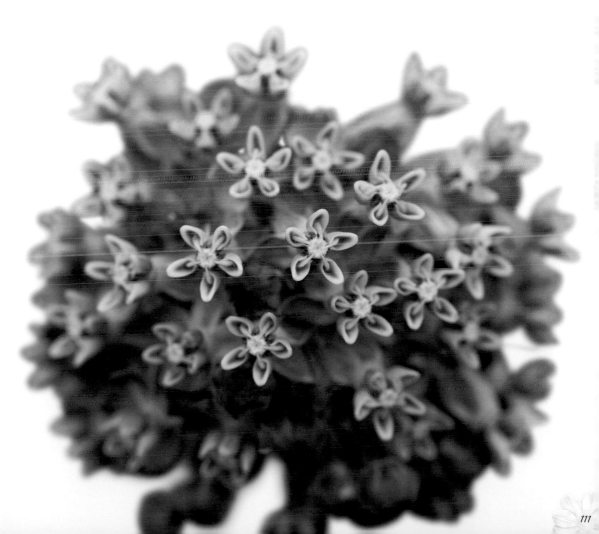

Common Milkweed

BUTTERFLYWEED

Butterflyweed is one of the showiest summer wildflowers. This perennial has large, flat-topped clusters of bright orange flowers that attract not only butterflies, as the name suggests, but also bees. The flowers are difficult to pollinate, so the flowers last a long time. Only a few flowers are successfully pollinated, and as a result, just a few large, pointed seedpods form. There are hundreds of seeds inside the pods. Each one is attached to a tassel of silky thread, which helps the wind carry the seed away from the mother plant.

A member of the milkweed family, Butterflyweed often grows in native prairies and is also seen along roadsides. It is found in dry, sandy soils in full sun. Monarch butterflies take nectar from the plants, and the females lay eggs on the leaves. Later, the growing caterpillars feed on the leaves.

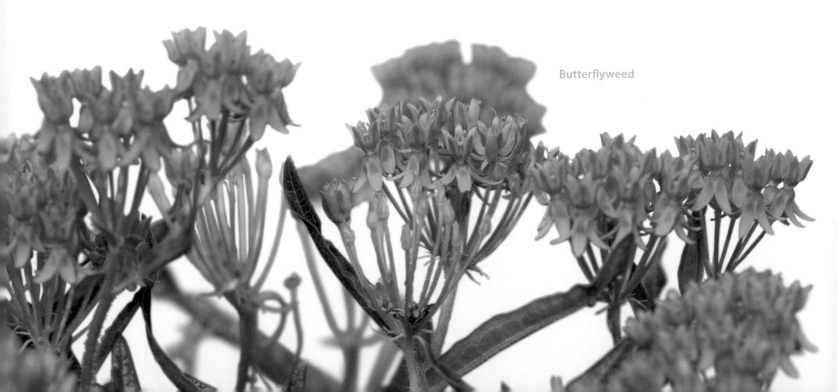

Butterflyweed

FIREWEED

Fireweed is sometimes called Willow Herb because of its long, willow-like leaves. This wildflower is found throughout the world. It is a pioneer species that grows first after a fire, hence the common name. It quickly establishes itself from seeds on the ground, reaching peak growth in the fifth year after a fire.

The plant is often seen in ones and twos, but it can also grow in large clumps or clusters. It has unique reddish stems with a tall spike of flowers. A wide variety of insects, including butterflies, visit its large flowers. The flower is unique, with four magenta-to-pink petals and four narrow, pointed pink sepals behind the petals, making it look like it has eight petals. After pollination, the small brown seed capsule contains about 300–400 seeds. Each plant has many capsules and can have over 80,000 seeds!

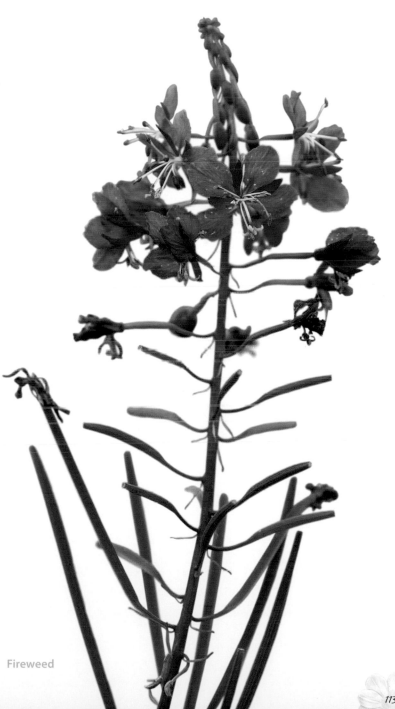

Fireweed

JEWELWEED

This remarkable annual wildflower goes by many different common names. Usually called Jewelweed, it is also known as Spotted Jewelweed due to the small dots or spots on its flowers. Another name, Spotted Touch-me-not, was given because its banana-shaped seedpods explode when touched.

Jewelweed grows in wet areas, reaching three to four feet in height. At maturity, it is covered with uniquely shaped yellow-to-orange flowers. The opening of the flower is large enough to allow large bumblebees to enter. The tubular-shaped flower ends with a hooked spur that is filled with nectar.

Seedpods are large and obvious. When ripe, they explode at the slightest touch. The pods are comprised of many thin strips (like the stripped peels of a banana) that roll back tightly and send the brown seeds many feet away from the parent plant. If you scrape the brown seed coat, you can see the sky-blue seed.

The plant has thick, translucent stems that exude a clear liquid, which has been used to treat the rash produced by Stinging Nettle. It has been shown that this plant juice has an antifungal agent. In late summer, hummingbirds spend a great deal of time visiting these wildflowers and complete a lot of cross-pollination.

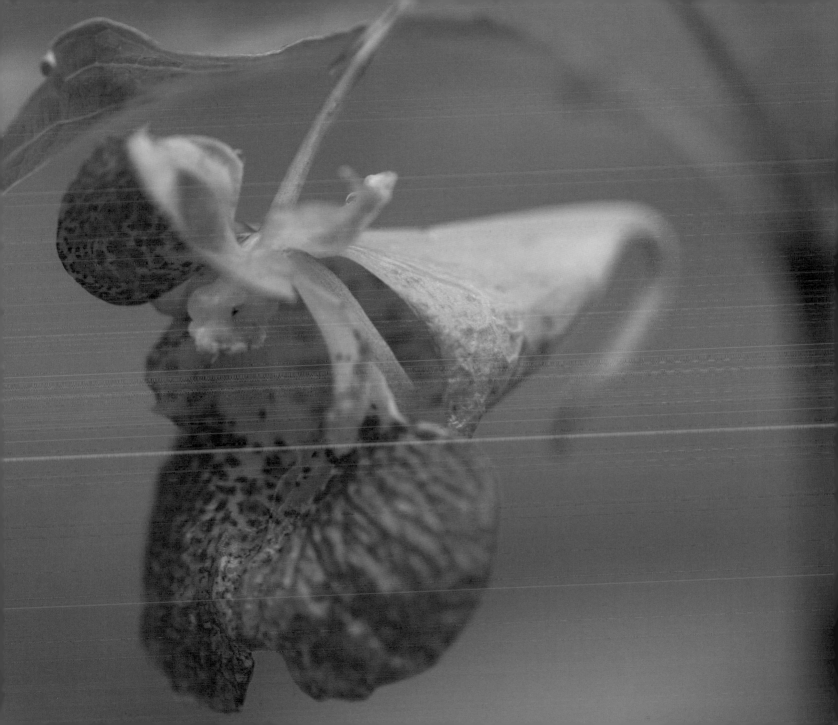

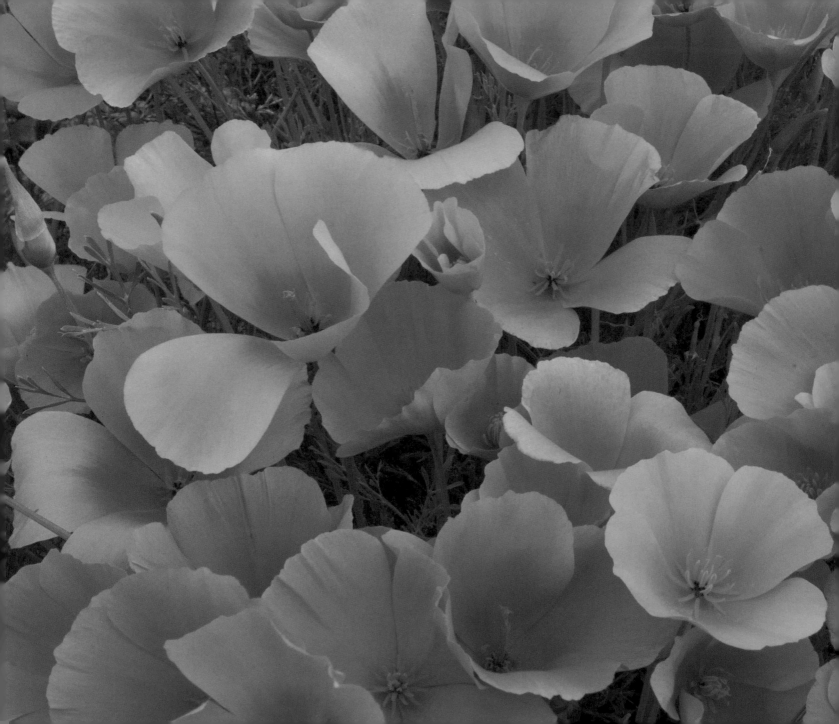

MEXICAN GOLD POPPY

From spring stretching into summer, in the deserts of New Mexico, Arizona, California and western Texas, a very special flower blooms. This eye-popping native wildflower of the American Southwest, called the Mexican Gold Poppy, is also known as the Desert Gold Poppy. It may bloom in spring if there has been enough rain during the winter. It blooms in summer providing it received adequate rainfall in the spring.

In the years when it blooms, entire mountainsides are covered in a riot of yellow-and-orange colors. Most of the flowers have yellow petals with an orange center. While there's not much of a fragrance, the bright color and large flowers get the attention of many flying insects. The flowers are known to attract at least 45 insect species, including bees, wasps and butterflies.

These flowers have been studied for their ultraviolet light-reflecting patterns, which help guide insects toward the nectar and pollen in the center of the blooms. Many sizes of insects visit the flowers, but the small insects don't help with pollination. Only medium and large insects pick up the pollen and move it to other flowers.

Mexican Gold Poppy

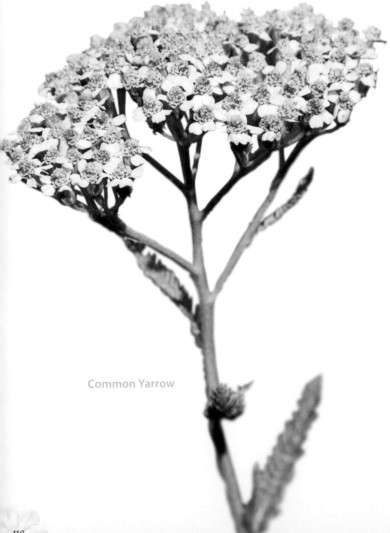

Common Yarrow

COMMON YARROW

The Common Yarrow is one of the most common wildflowers across the United States and Canada. This plant is also found in Europe and Asia and was introduced to other places, such as New Zealand. It grows along roadsides and in open fields from sea level to elevations up to 10,000 feet or more.

Common Yarrow is often confused with a type of fern because its leaves are highly divided, making them look like fern leaves. In fact, the species name *millefolium* means "thousand leaves" and refers to the many parts of its leaves. The leaves have varying amounts of hair (pubescence).

The plant has a large flat-topped cluster of white-to-cream flowers, which act as large landing pads for many insects. Many birds, such as starlings, use yarrow leaves in their nests. Yarrow is said to inhibit the infestation of insects and parasites.

INDIAN PIPE

Indian Pipe, a perennial in North America's temperate woodlands, is one of the more unusual wildflowers. What makes it so different is the lack of chlorophyll, which is the substance that makes plants green. Usually this plant is white with flecks of black, or in some cases, pink. Due to its ghoulish color, it is sometimes called Ghost Plant or Corpse Plant.

Instead of gathering energy through sunlight, like other plants, Indian Pipe gets its energy from other plants. It uses a fungus in the soil (mycorrhizal) to connect with tree roots, and then draws on the energy from the tree. Since it doesn't depend on sunlight to grow, it can thrive on shady forest floors during summer.

This plant doesn't have much for leaves. It grows something more like scales instead. The flowers are white and can be translucent. Each stem bears one flower with three to eight petals. The flower droops down, keeping out rainwater, and insects easily find and enter the flower. After pollination, the flower turns upright and produces a seedpod. You can easily judge the stage of pollination by the position of the flower.

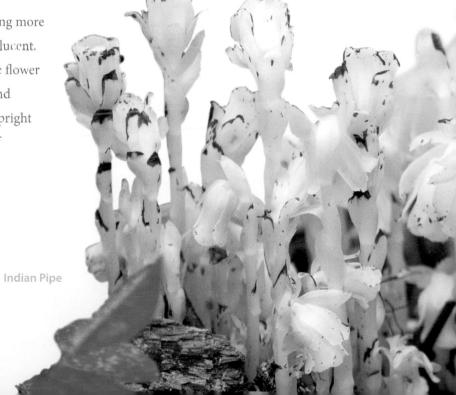

Indian Pipe

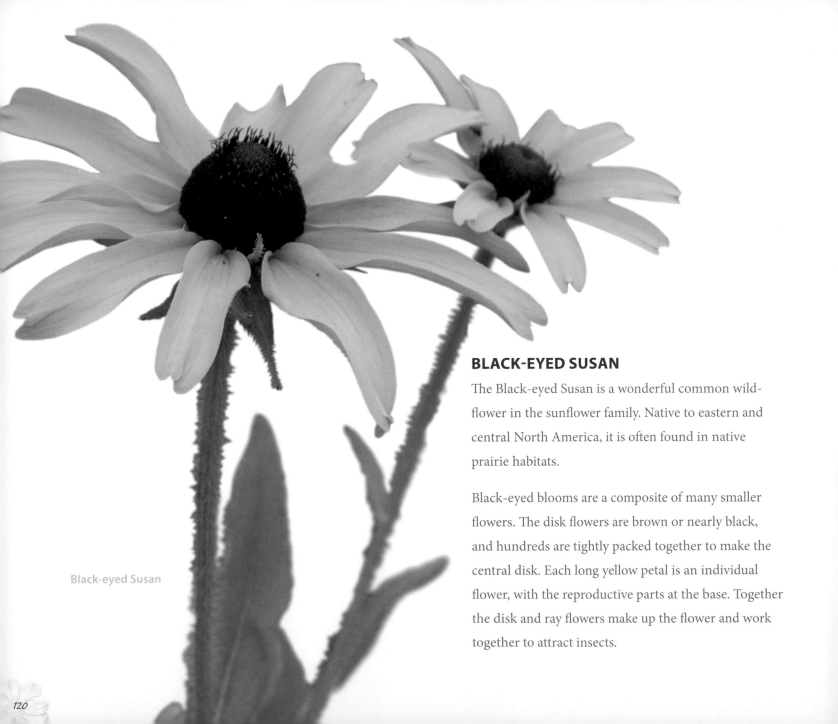

Black-eyed Susan

BLACK-EYED SUSAN

The Black-eyed Susan is a wonderful common wild-flower in the sunflower family. Native to eastern and central North America, it is often found in native prairie habitats.

Black-eyed blooms are a composite of many smaller flowers. The disk flowers are brown or nearly black, and hundreds are tightly packed together to make the central disk. Each long yellow petal is an individual flower, with the reproductive parts at the base. Together the disk and ray flowers make up the flower and work together to attract insects.

WOOD LILY

The Wood Lily, also called the Prairie Lily, often grows in open woodlands and wet prairies. Standing nearly three feet tall, it presents a large funnel-shaped orange or red flower on a vertical stem, with green leaves whorling around the stem. Stems often have just one flower, but they can produce as many as four blooms.

This gorgeous wildflower grows from an underground bulb and was once more common than it is now. In earlier times, American Indians gathered the bulbs for food and medicine.

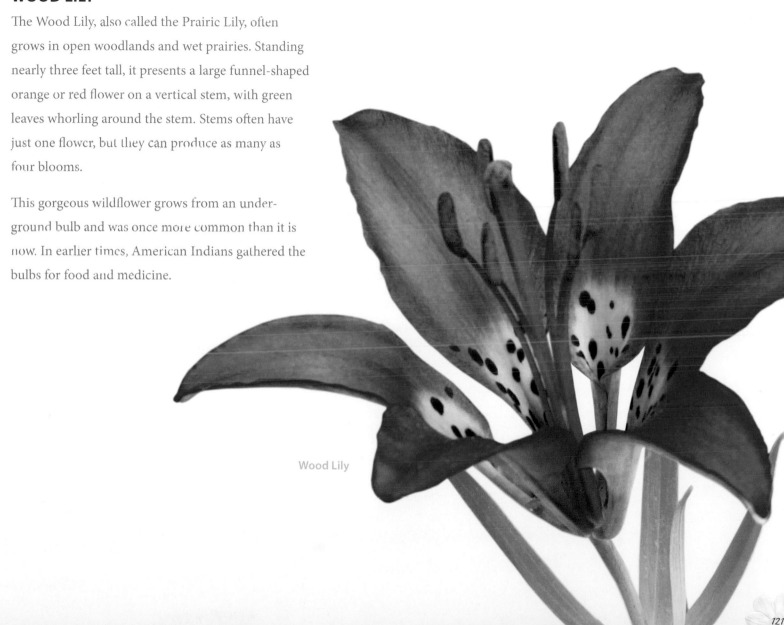

Wood Lily

QUEEN ANNE'S LACE

By midsummer, roadsides and fields explode with amazing wildflowers. Queen Anne's Lace, or Wild Carrot, colonizes disturbed soils and thrives where other wildflowers cannot. A non-native species in North America, it has expanded its range across much of the continent over the past century. It is now so common that it's considered naturalized, and in some states it's listed as a noxious weed. The flat-topped white clusters occasionally have a single dark purple or black central flower. After pollination, the flowers start to dry and close. At this stage, they resemble a bird's nest and are often used in dried flower arrangements.

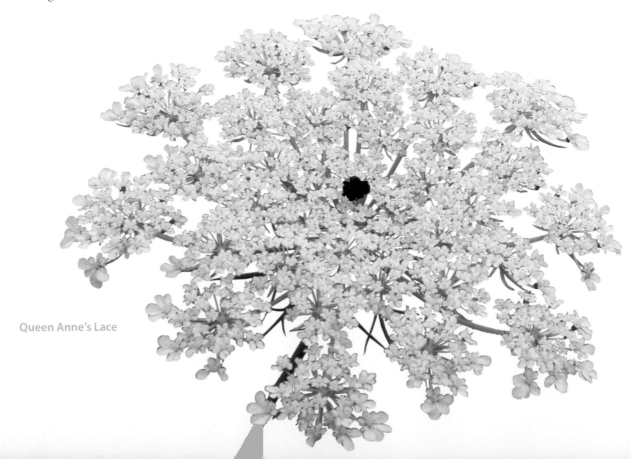

Queen Anne's Lace

Chicory

CHICORY

Chicory, also called Blue Sailor, opens its sky-blue
flowers at about the same time as Queen Anne's
Lace. The flowers open one at a time and last only
one day, yet the soft blue color stands out visually in
a landscape.

Closely related to the Common Dandelion, Chicory
was brought to North America as a garden plant.
The long taproot was dug up at the end of the season
for roasting and grinding into a coffee substitute or
additive. In some parts of the country, people still
add it to coffee.

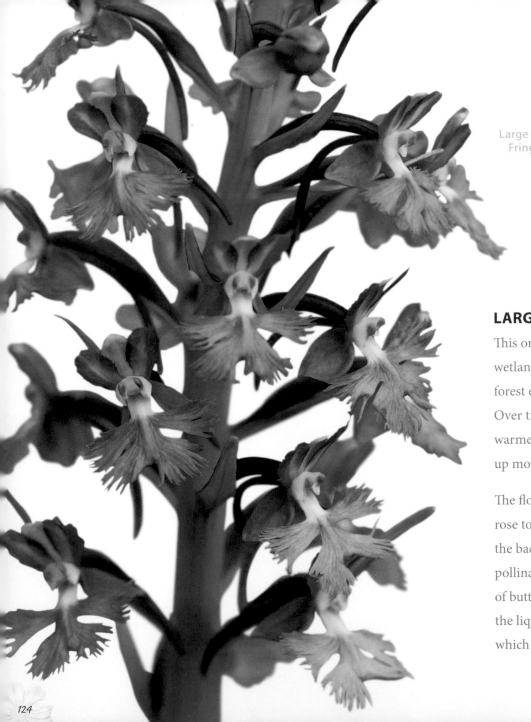

Large Purple
Fringed Orchid

LARGE PURPLE FRINGED ORCHID

This orchid is a stunning wildflower that grows in wetlands and sedge meadows, and along evergreen forest edges. It needs cool, moist summers to thrive. Over time, as the season's average temperatures get warmer, the range is pushing northward or heading up mountainsides.

The flowers are usually lavender but can vary from rose to purple (rarely white). A long tube (spur) in the back of the flower contains nectar. Flowers are pollinated when the long mouthparts (proboscises) of butterflies and moths slip inside the tube to sip the liquid. The insects become covered in pollen, which they carry to the next flower.

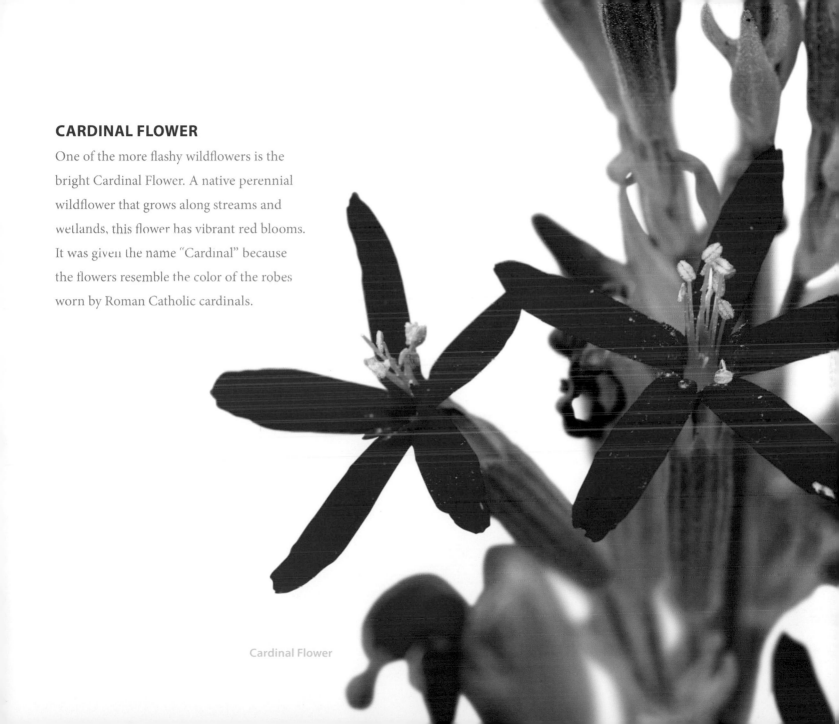

CARDINAL FLOWER

One of the more flashy wildflowers is the
bright Cardinal Flower. A native perennial
wildflower that grows along streams and
wetlands, this flower has vibrant red blooms.
It was given the name "Cardinal" because
the flowers resemble the color of the robes
worn by Roman Catholic cardinals.

Cardinal Flower

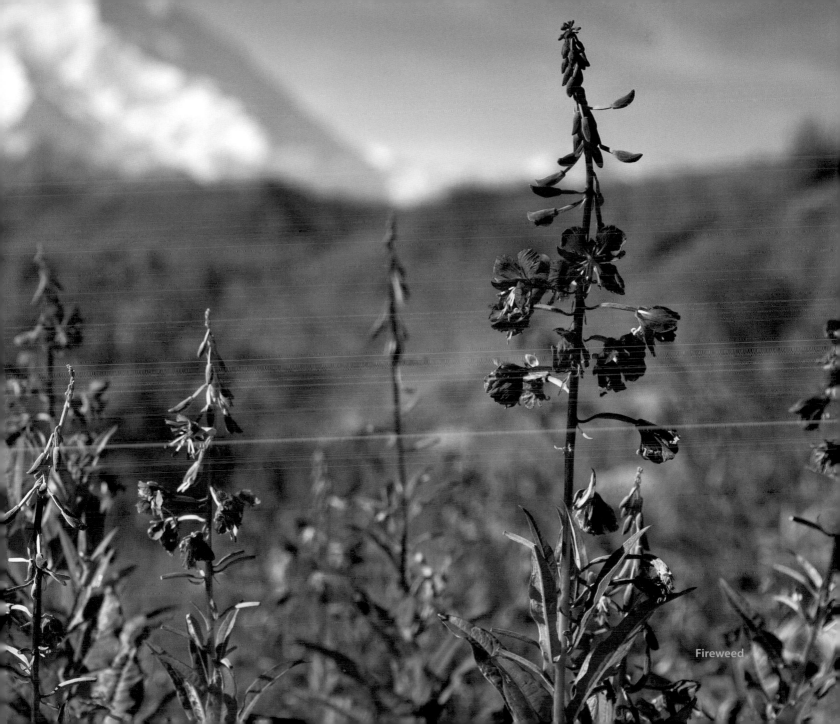

Fireweed

Late Bloomers

As the summer winds down and the vast majority of wildflowers are finished blooming for the year, there are still more wonderful species to enjoy. At this time of year, the bees and other insects are very busy collecting the last of the nectar and pollen before winter sets in. While there may not be a wide variety of wildflowers at this time, the new late bloomers can often be seen in large stands covering hillsides and roadsides.

Prairie Aster

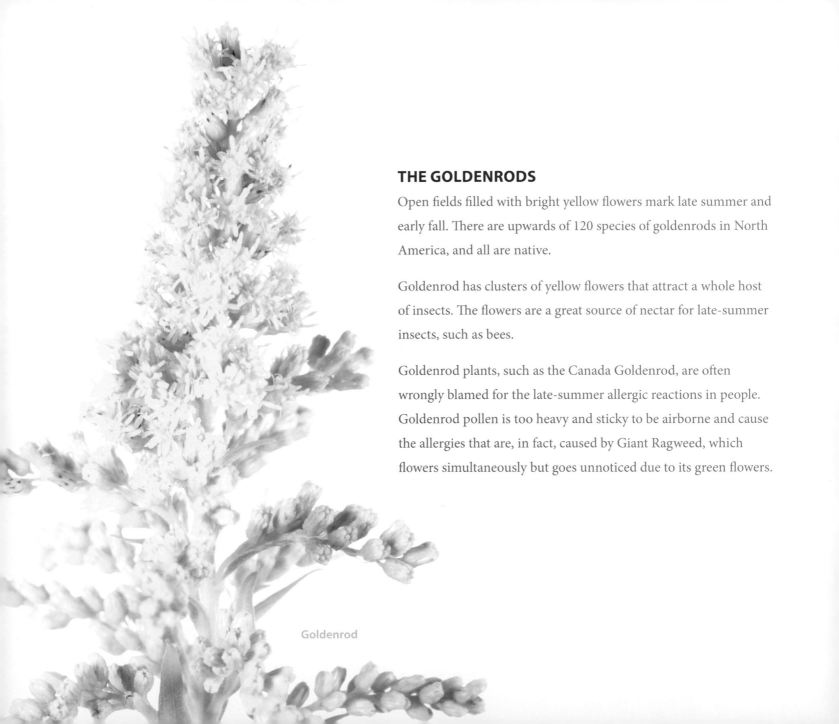

THE GOLDENRODS

Open fields filled with bright yellow flowers mark late summer and early fall. There are upwards of 120 species of goldenrods in North America, and all are native.

Goldenrod has clusters of yellow flowers that attract a whole host of insects. The flowers are a great source of nectar for late-summer insects, such as bees.

Goldenrod plants, such as the Canada Goldenrod, are often wrongly blamed for the late-summer allergic reactions in people. Goldenrod pollen is too heavy and sticky to be airborne and cause the allergies that are, in fact, caused by Giant Ragweed, which flowers simultaneously but goes unnoticed due to its green flowers.

Goldenrod

WHITE SNAKEROOT

White Snakeroot is a very common wildflower that blooms in the fall along shady deciduous forests. It is a member of the aster family, with flowers composed of just disk flowers (no ray flowers), giving it a unique appearance.

This woodland wildflower contains a toxin that historically led to an ailment called milk sickness. Snakeroot's toxin, when ingested by a cow, can be passed on through its milk. Today, with modern livestock practices and processing, milk sickness is no longer a health concern.

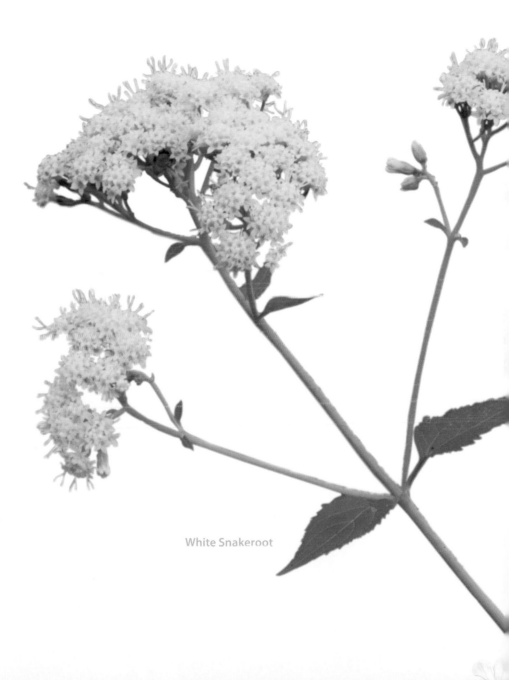

White Snakeroot

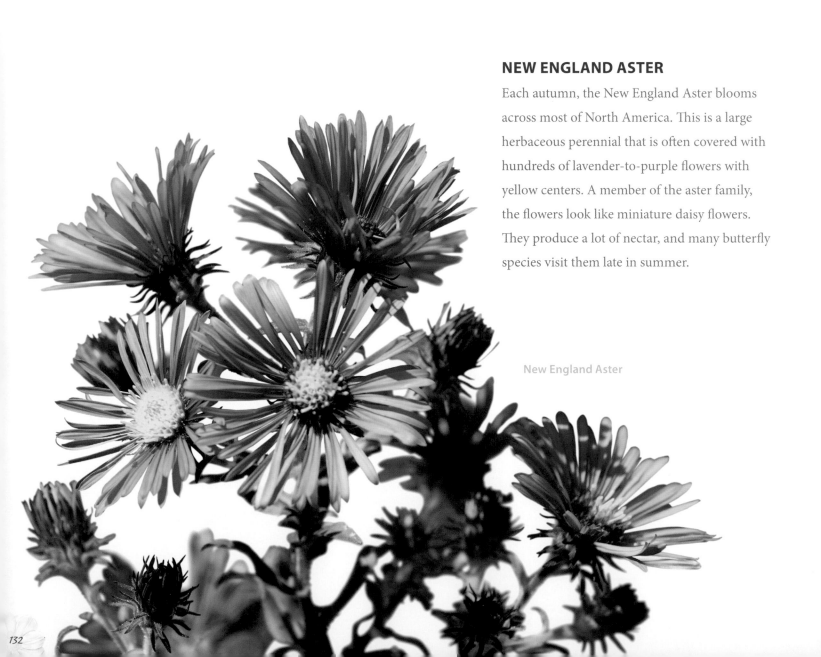

NEW ENGLAND ASTER

Each autumn, the New England Aster blooms across most of North America. This is a large herbaceous perennial that is often covered with hundreds of lavender-to-purple flowers with yellow centers. A member of the aster family, the flowers look like miniature daisy flowers. They produce a lot of nectar, and many butterfly species visit them late in summer.

New England Aster

BONESET

Boneset is a tall, forest-edge wildflower with a large cluster of white flowers. It is one of the few late-season wildflower bloomers, and it's easy to identify. It has large crinkled leaves with a wide base that grows around the stem, which makes the stem appear to be growing through one large leaf (perfoliate). It was once believed that the odd leaf growth meant that the plant could be used to help set broken bones, hence the common name.

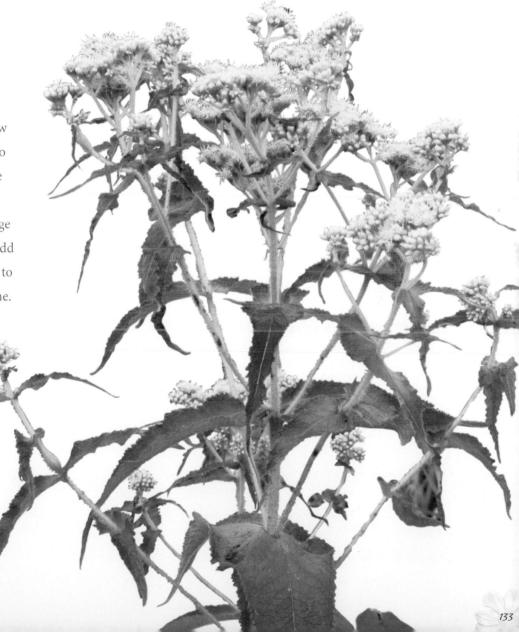

Boneset

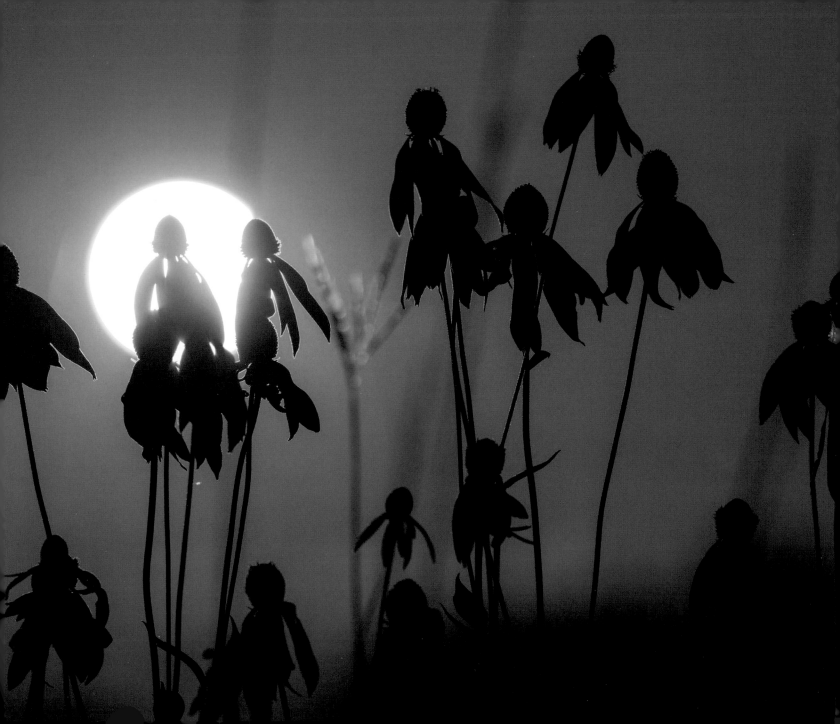

Beauty in Form and Function

We are surrounded by a wide variety of wildflowers nearly all year long. Some are small and delicate and hard to notice, while others are large and showy and cover vast areas. There are thousands of plants that can be considered wildflowers. Some grow only in specific habitats, and others grow just about anywhere. We grow some wildflowers in our gardens for their beauty and grace. Others are so wild that they can't be tamed and cultivated at all.

A world without wildflowers is hard to conceive, and yet we often don't notice them as we go about our daily lives. I think all wildflowers, whether they are tiny and inconspicuous or big and flashy, are remarkable in both form and function. They bring so much more to the world than man-made things to look at and admire.

We must remember that wildflowers are not here for you and me. They are here to attract insects that benefit from eating pollen or sipping nectar. In exchange, by cross-pollinating, insects help wildflowers produce seeds that grow to become stronger and healthier plants with each succeeding generation. This is how nature keeps going strong.

When you understand the roles that wildflower plants play in the big picture of the natural world and see them for what they are, I think you will come to appreciate them even more. You can think of plants in general as the foundation, or cornerstone, of all life on the planet. Every living thing depends on plants for life. And the flowers that the plants produce are the sweet icing on the life-giving cake.

I hope you enjoy this book and its unique look at wildflowers. Perhaps it will spark your own interest to go out to see and learn more about our amazing wildflowers.

Gray-headed Coneflower

About the Author

Naturalist, wildlife photographer and writer Stan Tekiela is the originator of the popular Wildlife and Nature Appreciation book series that includes *Bird Migration* and the award-winning *Feathers*. Stan has authored more than 190 educational books, including field guides, quick guides, nature books, children's books, playing cards and more, presenting many species of animals and plants.

With a Bachelor of Science degree in Natural History from the University of Minnesota and as an active professional naturalist for more than 30 years, Stan studies and photographs wildlife throughout the United States and Canada. He has received various national and regional awards for his books and photographs. Also a well-known columnist and radio personality, his syndicated column appears in more than 25 newspapers, and his wildlife programs are broadcast on a number of Midwest radio stations. Stan can be followed on Facebook and Twitter. He can be contacted via www.naturesmart.com.